yabu pushelberg

The Development of the American Modern Style

Studies in the Fine Arts: Architecture, No. 8

Stephen C. Foster, Series Editor

Associate Professor of Art History
University of Iowa

Other Titles in This Series

The Development of the American Modern Style

by
Deborah Frances Pokinski

UMI RESEARCH PRESS
Ann Arbor, Michigan

Produced and distributed by
UMI Research Press
an imprint of
University Microfilms International
A Xerox Information Resources Company
Ann Arbor, Michigan 48106

Library of Congress Cataloging in Publication Data

Pokinski, Deborah Frances.
The development of the American modern style.

(Studies in the fine arts. Architecture ; no. 8)
Revision of thesis (Cornell University, 1982)
originally presented under title: The most appropriate
style.
Bibliography: p.
Includes index.
1. Architecture, Modern—19th century—United States.
2. Architecture, Modern—20th century—United States.
3. Architecture—United States. I. Title. II. Series.
NA710.P64 1984 725'.2 84-2565
ISBN 0-8357-1567-1

To my mother and father

Contents

List of Illustrations

Preface

It is well understood by most historians that what they deal with is rarely the truth and certainly never the whole truth. Most of us would readily acknowledge that this is a blessing since the whole truth would probably be completely unmanageable. History, as we know it, is the most honest effort to recover, order and make sense of the chronicle of human events and ideas. At its best, it is selective, but it aspires to the most complete and fair assessment of a body of knowledge, to suggest the most salient and consequential events and ideas of a time so that we may understand it better. Often, this is not what happens. Often, for reasons which are not intentionally disserving, something which is incomplete or inaccurate becomes history. Such is the power of history that even the incomplete and inaccurate can be made to appear reasonable and true.

The discovery of this unreliable quality is what committed me to history. I became intrigued by the process of history: by how and why one historical assumption or assessment comes into being and not another or why one prevails and not another. I found that trying to unravel conclusions in order to discover how they developed and to recognize the context which encouraged them was the most interesting and satisfying, the most exciting part of history. It was like penetrating into a secret room, a place beyond history and much closer to understanding what I most wanted to know about — why humanity comes to believe the things it does: how it gives definition to itself consciously and unconsciously.

At some point I realized that behind generally accepted historical views, particularly those that tend to sound categorical, there is usually another story. One such history is that of modern architecture. It seemed to me that much of the generally accepted view of the development of modern architecture was peremptory in tone. That led me to wonder, in particular, why so many were so sure that aside from Louis Sullivan and the so-called Chicago School, America contributed almost nothing to the growth of modern architecture. This assumption was especially puzzling in light of the apparently easy and pervasive conquest the International Style made in America in the 1950s and 60s. If this country was so staunchly antimodern, I wondered, what caused it to change so abruptly.

I believe that the reason why the conventional view came to be and to prevail for so long is simple: most of what we read concerning the history of modern architecture was written by a generation of authors directly involved with and committed to the precepts of avant-garde European architecture. They saw everything in light of its promise and passed judgments according to how other forms compared to this ideal, and their judgments prevailed simply because modern architecture prevailed.

In order to recover another side to this story, and to gain a more accurate understanding of the concerns and intentions of American architects between 1893 and 1933, I chose to return to the American architectural journalism and history of the period itself. What I found confirms the existence of a long ignored, but highly consequential process by which modernism was generated among American architects and which, furthermore, indicates a distinct American tradition of modernism.

I would like to clarify several points in regard to the organization and content of this study. Generally, I found that a chronological format was the most straightforward for the purposes of this study. With one exception I have followed this pattern. Chapter 2 following the introduction, does not deal, as one might expect, with the World's Columbian Exposition of 1893 and the development of steel-framed commercial architecture. These are covered in chapter 3. In chapter 2, I compare the European concept of modern architecture with the American view, particularly as each is presented and at times synthesized by Henry-Russell Hitchcock and Philip Johnson in their 1932 publication, *The International Style*. Initially, I assumed that I would discuss this essay at the conclusion of my study, within the time period 1929 to 1933. Only after I had completed most of my research, and reread *The International Style* in preparation for discussing it in this new context, did I discover that Hitchcock and Johnson, far from restating European values and theory, actually described American attitudes, values and expectations about architecture, which were very different, in fact, from the European concepts. Because of my own recently formed perspective on this period, I realized that Hitchcock and Johnson reflected in *The International Style* the very attitudes and expectations that I now understood to have developed in the United States throughout the forty years between 1893 and 1933. It was then that I decided to use this important discovery as the springboard of my study and to place the discussion of *The International Style* at the beginning of the work rather than in chronological sequence.

Although I believe that the answer is apparent in the full context of the study, the reader may at first wonder why I have omitted all but the briefest references to Frank Lloyd Wright and why I have concentrated exclusively on commercial skyscrapers as architectural examples, while ignoring domestic architecture. The reasons are, in fact, related: first, contemporary architectural journalism, which was my major source, indicated that Ameri-

can architects of the period were primarily interested in skyscrapers, and second, Frank Lloyd Wright did not receive much critical attention at that time. Wright was not favored in the architectural press for several reasons: first, he was primarily considered to be a domestic architect; second, his work was evaluated as too individualistic and, therefore, out of the mainstream; and third, his irregular personal life made him a less than sympathetic figure. I have, in my study, tried to reflect the prevailing concerns and attitudes as revealed in the contemporary journalism. The facts that Europeans recognized Wright's genius long before his compatriots responded to his work and that domestic architecture in this country remains a secondary concern, without the prestige attached to monumental forms, are indeed further indication that American and European attitudes and expectations about architecture were very different.

It is a pleasure to thank those people who helped me in bringing this study to a successful conclusion. I would like to acknowledge Esther Dotson, John Reps, Robert Calkins and the late Stephen Jacobs for the guidance and inspiration I received from them during my graduate studies at Cornell University. To John Reps and Esther Dotson, both of whom read the manuscript as a dissertation, I owe special thanks for their careful suggestions and wholehearted support. Several other colleagues and friends read parts of the manuscript and I am very grateful to Betsy Adams, Alma Zook, Barbara Tewksbury and Paul Zygas for their assistance. Ralph Lieberman read the entire manuscript and his discerning editorial pen immeasurably improved the prose. More than this, his sensitive and incisive art-historical eye challenged my thinking and writing toward a level of excellence I hope one day to master.

I would like to express my gratitude to my colleagues in the Art Department of Hamilton College in Clinton, N.Y. and to the Dean of the College, C. Duncan Rice, for their support in arranging a semester leave during which I completed the original manuscript. I would also like to thank David Tewksbury of the Hamilton College Audio-Visual Department for printing, and often reprinting, the reproductions which illustrate the text. Very special thanks to Debbie Barnes and Julie Kisiel who typed the manuscript and without whose skill, patience and good humor everything would have been much more difficult.

My deepest gratitude goes to Ted Brown. I owe him the greatest and most appreciated intellectual debt. His skepticism of historical conventions brought me to him and he disciplined and tutored my own reassessment of them. A large part of the merit of this work I owe to him.

Some thanks are difficult to express. My parents have always had a special respect for learning and education and they have never wavered in their belief that I was worthy of pursuing them. Their support has always been understood and I take the greatest pleasure in dedicating this work to them.

1

Introduction:
The Appearance of a Myth

> Such a mythology, in which the extremes of eclectic depravity are sharply and cleanly contrasted against an architecture of high moral tone.
>
> Colin Rowe, 1954

In 1931, architecture critic Lewis Mumford expressed his dismay that American architects were still not capable of designing modern architecture. Seeking to explain this conspicuous failure, Mumford had concluded that, following the impact of the Renaissance-inspired architecture of the 1893 World's Columbian Exposition, American architects were led "to wander for forty years in the barren wilderness of classicism and eclecticism,"[1] and thus had little comprehension of modern design.

Ever since Mumford expressed that opinion, the years 1893 to the mid-1930s have been conventionally viewed as a "dark age" in American architecture. According to this view, an early initiative toward modernism by Louis Sullivan and the so-called Chicago School of commercial architecture was swept away after the 1893 Exposition by a relentlessly reactionary approach to architectural design which continued unabated until American architecture was delivered in the mid-1930s by the intervention of European avant-garde ideas. This view—which essentially denies any significant development toward a modern American architecture after 1893, and presumes that modern architecture was accepted into the United States only after about 1933 in the guise of the European International Style—soon became the accepted assessment and was widely disseminated by the major apologists of modern architecture. It is this view which is advanced, for example, by Sigfried Giedion in *Space, Time and Architecture*:

> After the structural forthrightness of the first Chicago School during the eighties, after Louis Sullivan's outstanding purity of architectonic expression and Frank Lloyd Wright's exciting example around 1900, the spirit of American architecture had degenerated into a mercantile classicism.[2]

It is an important aspect of this view that degeneration was due to the insidious inspiration of the Chicago Fair of 1893 with its Renaissance revival architecture: "the crushing assault of Beaux Arts academicism on the remnants of progressive architecture during the early twentieth century," which "overwhelmed Louis Sullivan and eventually the entire Chicago school of naked skyscraper construction."[3] The American architects of the Fair are presumed to have abdicated their creative responsibility and abandoned all interest in, and comprehension of, contemporary problems by succumbing to the insipid but familiar charm of classicism and eclecticism and then to have spread this attitude like a pall over the architectural thought and practice of the next four decades. "The impulse to break free from this disastrous development," wrote Giedion, "had to be initiated from the outside."[4] Moreover, he and other modernists have written that the time and the impulse for that break did not come until the *late* thirties.

This image of a "dark age" has endured for years and, bolstered by the promotion of writers such as Giedion, has proven to be indelible: so indelible that, in the history of American architecture, the years between 1893 and the coming of European modernism in the 1930's are generally ignored. As a result, the crucial significance of these years, for the development of later architecture and for the acceptance of modernism in America, has been overlooked. In fact, these years were never the "barren wilderness" Mumford described. Beginning before the 1893 Fair and continuing throughout the next four decades, certain progressive ideas, usually associated only with the modern movement, were considered and discussed intensively, very often by architects and critics who are now considered to have been conservative or even reactionary. A closer examination of this period, which this study undertakes, reveals that the development of modernism in American architecture was already underway during these years. Indeed, by 1933 it had come to maturity. It did not have to await an impulse from Europe.

The most important issues discussed by Americans during this period, and those most significant for modernist developments, were three: first, the creation of a national style; second, the appropriate expression of function; and third, the resolution of the paradox between historically based architectural design and the unprecedented steel frame structural system for tall buildings. These, in fact, presaged the major issues of modernism and were to be resolved, particularly in the United States, in the creation of what we now call modern architecture. Therefore, they form the underlying themes of this study.

More significant, however, than the issues themselves, or even the discussions they provoked, were the dynamics of those discussions. The discussions of these particular issues generated a process of change, in architectural attitudes and practice, and this process, not the introduction

of European modernism, is what eventually gave rise to modernism in American architecture. This study therefore undertakes an examination of those discussions, in order to trace the pattern of change and appreciate the actual process of "modernization" in American architecture.

It seemed both convenient and appropriate to define the chronological bounds of this complex and consequential process with the years 1893 and 1933; indeed, these limits appear to be inherent in the history of the period. The World's Columbian Exposition of 1893 in Chicago, with its overwhelming assertion of historical precedent, was, by almost unanimous agreement, a landmark event in American architectural history (fig. 1). Although it later came to be considered by historians of the modern movement as the deathknell of early functionalism, the Fair was regarded by contemporaries as the dawn of an American Renaissance. Furthermore, at more or less the same moment and also in Chicago, American architects began the extensive use of metal skeleton construction in major buildings. Although highly controversial at first, this too was considered profoundly significant by a wide spectrum of people, from the most progressive to the most traditional. Appropriately, the period and the process opened with two events which on the surface appeared to be completely contradictory. It closed in 1933, also in Chicago and also with a fair. In fact, the 1933 Chicago Fair had strong and conscious associations with the 1893 Fair. The architects of the Century of Progress (fig. 2), as the 1933 Fair was called, quite consciously desired to repeat, if not surpass, the legendary architectural impact of the 1893 Fair. These architects were determined to embody the modern American spirit of 1933 in architecture. But whereas the architects of the World's Columbian Exposition had turned to historic precedent to "mirror [those] times with rare fidelity and a great dignity,"[5] the architects of the Century of Progress deliberately set out to reflect a modern, "blue-steeled determinism and cold, white logic."[6] Moreover, plans for the Century of Progress Exposition proceeded at the same time that the organization of the first exhibition of modern European architecture was underway, sponsored by the recently founded Museum of Modern Art in New York City. Held in 1932 and organized by Philip Johnson and Henry-Russell Hitchcock,[7] this exhibition proclaimed their interpretation of an "International Style" of modern architecture based on European examples. Finally, by 1933 construction of monumental architecture in the United States all but ceased.[8] Nevertheless, all of the skyscrapers completed by that date exhibited the influence of modernist attitudes in their designs.[9] The Fair, the Exhibition and the skyscrapers, together, by 1933 already manifest a clear American awareness of and commitment to modern architecture. Indeed, by that date, a most crucial and active process of development for modern architecture in America had already been completed.

The richest source for reconstructing the discussions of this period, and

examining the process of change they represent, is the large body of architectural journalism generated by contemporary architects, critics and concerned laymen between 1893 and 1933. Architecture, in fact, seems to have been a favorite topic in this period, to judge by the numerous articles in both professional and nonprofessional journals, as well as the substantial number of new architectural journals which began publication at this time.[10] The period also saw the first full-scale studies of American architecture, examining its past, its present and, invariably, its future. Book-length works by Lewis Mumford, Sidney Fiske Kimball, Talbot Hamlin, Thomas Tallmadge and George H. Edgell appeared between 1924 and 1931.[11]

Even a general examination of these sources, both articles and books, will affirm the persistent aspirations for a national style, coupled with the need to reconcile the unprecedented and admittedly progressive new architectural technology with an existing design methods based on historical precedent. On the other hand, as the literature also reveals, a concern for these basic issues did not necessarily or consistently imply a modernist view during this period. These aspirations and preoccupations originated as nineteenth-century attitudes about the nature of architecture and for much of the period remained fixed within the earlier, more traditional context.

The most pervasive and deeply entrenched attitude about architecture inherited by Americans from the nineteenth century was that architecture should express a nation's genius and embody its greatness: that the state of a nation's architecture reflected its inherent character. As Claude Bragdon, architect and critic, wrote in 1909:

> Architecture . . . images at all times a nation's character, changing as that changes. It is the mirror of the national consciousness. It cannot lie The peculiar genius of any given race or any given period incarnates, as it were, in some architectural construction characteristic, and therefore symbolic of it.[12]

This historicist attitude, which was so pervasive during the period, encouraged an exaggerated concern with, and respect for, aesthetic traditions or styles of the past because they were considered to embody the genius of the great civilizations of history. As a result, the respect paid to the past over time solidified into a practice in which all architectural design was based on historical precedent. Few would ordinarily conceive of a style which did not relate to an historical source. In fact, the idea of architecture outside of this stylistic definition was an anomaly to many of the early architects and critics of the period. Architectural means and methods which were incompatible with historical precedent were outside their shared expectations for architecture and left them at a loss to determine the aesthetic quality of unexampled phenomena, such as the steel-framed skyscraper.

Only gradually was this dilemma to be resolved. It is important to remember, however, that American architects never entirely rejected the past; they believed firmly in continuity of development and they relied on precedent throughout the period, even into the development of modernism.

Moreover, a traditional concept of style remained vital in this country. Americans continued to show a strong predilection for understanding architecture in terms of a distinctive decorative or formal treatment of surface: a style, whether historic or modern. The European insistence that style was irrelevant to modern architecture was foreign to American thinking.

Nevertheless, functionalism—the expression of the structure, materials, or use of a building—was also a well-established interest of nineteenth-century architecture, but more equivocal, especially concerning style and decoration, than its twentieth-century counterpart. Among the manifestations of nineteenth-century functionalism that were admired and called upon for emulation were rationalist approaches to the integrity of materials and structure and a certain severity in composition such as characterized the work of architects like Schinkel in Germany and Labrouste in France. Viollet-le-Duc's interest in the rational nature of Gothic construction led him to an appreciation of modern engineering and new materials, especially metal framing. Because of his great authority and prestige he was able to lend these technological innovations greater architectural respectability. However, none of these "functionalists" completely eschewed decoration in architectural design. In fact, the German architect and theorist Gottfried Semper advocated the expression of the function of a building through its plan and its composition, including any decorative elements. The English critic John Ruskin, who probably had more influence in this country than any nineteenth-century theorist, sanctioned a distinction between architecture and mere building and placed a premium on the inclusion of appropriate ornament in architectural design. Therefore, many American architects were inclined to consider exposed structure as unfinished or ugly, to regard buildings with a commercial function as mere building, and to view the expression of function as a matter of choosing a style most appropriate to, or most compatibly associated with, the use of the building, while not necessarily disguising the actual construction.

The use of steel skeleton construction in the tall building, later called the skyscraper, gave rise to the most serious challenge to this practice and created the most significant paradox of the period. Indeed, it seemed to have catalyzed the process of change. The American fascination with this form began very soon after it first appeared. This was also an outgrowth of the historicist attitude, because, in spite of its unprecedented form and structure, the tall building was proudly recognized as indisputably American and this country's indigenous contribution to the architectural reper-

tory. A professor of architecture at the University of Pennsylvania explained this attitude in 1894:

> There has been developed among us a form of structure which, while not fulfilling the requirements of a new "style," . . . has nevertheless a character of its own sufficiently definite and distinctive to make it an American type. This is the high office-building.[13]

Although often cast in nineteenth-century terms, the basic issues that would characterize modernism in America predated the clear emergence of that movement. A straightforward or polemical unfolding of modernist attitudes, however, would have been highly unlikely, considering some of the deeply held convictions inherited from the nineteenth century, particularly regarding the value of precedent and the nature of style. Indeed, the confrontation of these traditional views with the eminently practical, but irrevocable and anomalous technology of the steel frame, provoked perplexing discussions filled with contradictions, rationalizations, and often erroneous conclusions. Nonetheless, the volatile nature of such discussions and debates in turn generated the process by which former attitudes and beliefs were revised, stretched, reworded and reconstructed to accommodate the new phenomena, while other priorities or methods were re-evaluated and reversed or rejected.

A proposition which challenges the accuracy of the conventional assumptions about American architecture between 1893 and the mid-1930s has not been considered in the history of modern architecture. On the other hand, this proposition also challenges the conventional, polemical view of modern architecture in general. It is very likely, in fact, that the polemical nature of the conventional view of modern architecture is responsible for the misinterpretation of the American development. Viewing the American scene with a bias toward architecture of exceptional form and revolutionary theory, the major apologists for the modern movement ignored a process which did not conform to their concepts, and disseminated what is essentially a myth about American architecture of the period: a myth in which Colin Rowe sees "the extremes of eclectic depravity . . . sharply and cleanly contrasted against an architecture of high moral tone."[14] Furthermore, in the context of an immensely influential exposition of the modern movement, such as Giedion's *Space, Time and Architecture*, a presumption of American reaction assumed the force of history. In the end neither the myth nor the reality can be explained without understanding that each has a distinct relationship with the more general development of modern architecture: that each is a significant aspect of the history of modern architecture.

The conventional view of modern architecture, still potently polemical, is based on a handful of contemporary essays, primarily European in origin and attitude and familiar to every student of the subject.[15] Issues such as the

expression of function and the appropriate use of unprecedented structural forms, the same issues which Americans were debating, formed the basic themes of these essays. However, one work, *The International Style* by Henry Russell-Hitchcock and Philip Johnson,[16] is distinct among the others. The attitudes assumed by the authors are what distinguish it and what proved to be especially significant to this study. Published in 1932, very near the close of the period under study, it was the only prominent analysis of the early modern movement in architecture *written by Americans*. As such it reflects some particularly American attitudes toward modernism. Hitchcock and Johnson, both relatively young men at the time,[17] had grown to maturity toward the end of this period of ferment and evolution, and their essay reveals that they were appreciably influenced by the concerns and debates which filled those years. Especially indicative is their concentration on the idea of *style*, a predilection which has usually been overlooked.

Indeed, the important consequence, if not the conscious motive of the essay was to define a style, specifically "a single new . . . contemporary style . . . unified and inclusive."[18] Moreover, they firmly placed the emergence of the new style, which they called the International Style, within the context of the nineteenth-century search for a representative style and even conclude that it was the ultimate solution to that search. The introduction to *The International Style* clearly presents "The Idea of Style":

> Since the middle of the eighteenth century there have been recurrent attempts to achieve and to impose a controlling style in architecture such as existed in the earlier epochs of the past
>
> The nineteenth century failed to create a style of architecture because it was unable to achieve a general discipline of structure and of design in the terms of the day. The revived "styles" were but a decorative garment to architecture, not the interior principles according to which it lived and grew
>
> Now that it is possible to emulate the great styles of the past in their essence without imitating their surface, the problem of establishing one dominant style which the nineteenth century set itself in terms of alternative revivals, is coming to a solution.[19]

Hitchcock and Johnson regarded style as the crucial issue in 1932: also of the years immediately before. Their definition of the International Style of modern architecture grew as much from the ideas debated in America between 1893 and 1933, as from the examples of European modernism they described.

Moreover, in their essay Hitchcock and Johnson articulated three essential characteristics of the new style. First, it used "modern construction throughout." Second, it "serve[d] function directly." And third, it was "completely freed from the conventions of the past," that is, free of "applied ornamental decoration."[20] Although these characteristics were

drawn, most immediately, from the European models examined by Hitchcock and Johnson, they also bear a significant relationship to the issues, especially those surrounding the skyscraper, that were debated in America during the preceding decades. Americans had for some time been struggling to accommodate the steel-framed building, usually associated by them with commercial functions, with an appropriate style — even to the extent of considering the abandonment of ornament. Because it has long been assumed that on the crucial matter of the characteristics of the International Style Hitchcock and Johnson were espousing the European examples exclusively, the extent to which they would have been familiar with these issues from the American context alone has never been appreciated. However, once one realizes the full measure of architectural development in America between 1893 and 1933, it becomes apparent how much of the American attitude they reflected and how intertwined with one another, in heretofore unexpected ways, are the developments of modern architecture in Europe and those in America.

Therefore, rather than as a wilderness or a dark age, the period between 1893 and 1933 and the dynamics of its discussions might better be visualized as giving rise to a transformation of architectural thought that, once set in motion, proved inescapable and essential. It is in the sense of an evolution that we must understand the development of modern architecture in America. It cannot be considered as the precipitous intervention of European modernism, but rather as a gradual unfolding of change akin to what Thomas Kuhn described as the structure of scientific revolution: "an intrinsically revolutionary process . . . of assimilation require[ing] the reconstruction of prior theory and the re-evaluation of prior fact . . . that is seldom completed by a single man and never overnight."[21] Revolution is seldom an abrupt, clearly discernible demise of the old and birth of the new. It is usually an imperceptible, often bewildering commingling of the two. Its age is usually one of paradox and contradiction. The time in America between 1893 and 1933 is such an age, and the evolution in architectural thought during those years is such a revolution.

It is the thesis of this study that, contrary to the conventional view, substantive architectural discussion in America between 1893 and 1933 gradually transformed both thought and practice and is, therefore, the most crucial factor in the development of modern architecture in America. Discussion began with deeply held traditional convictions, but also presaged the major issues of modernism. It eventually fostered attitudes which made possible the assimilation of European modernism and, at the same time, gave rise to a distinctive American variant of modernism most closely associated with the skyscraper. Essentially, architectural discussion from this crucial period led to a new conviction, apparent as early as 1933, that modernism was *the most appropriate American style* of architecture.

2

Differing Concepts of Modern Architecture: American "Style" and European "Ideology"

> . . . the problem of establishing one dominant style, which the
> nineteenth century set itself in terms of alternative revivals, is coming
> to a solution.
>
> Hitchcock and Johnson, 1932

> A breach has been made with the past which allows us to envisage a
> new aspect of architecture.
>
> Walter Gropius, 1937

Modern architecture is generally understood as the creation of exceptional and unific forms based on revolutionary theory. This is the essence of the conventional view of modern architecture that has existed for some time. In this conventional view the notion of exceptional form is derived from the insistence that modern architecture mades use of modern construction and materials: construction and materials developed from unprecedented technological advances. The sense of unific forms is based on the belief that in modern architecture, interior and exterior, space and plane, are organically related and should not be conceived one without the other. The revolutionary theory of modern architecture is understood to be functionalism: the direct expression of structure, materials and use. Moreover, functionalism is also the aesthetic premise of modern architecture; in other words, whatever is elegant of function will be inherently elegant of form and need no added embellishment. Finally, modern architecture is commonly considered polemical: an expression of the exceptional and revolutionary modern epoch.

These essential concepts underlie the prevailing definitions of modern architecture. Conventionally these concepts are ascribed to those considered to be the original masters of the modern movement, *almost without exception, all Europeans, but particularly Le Corbusier in France and Walter Gropius and Mies van der Rohe in Germany*. Furthermore, it is generally accepted that the Europeans developed the essential principles of modern

architecture, and that only then was the fully formed architecture introduced into the United States as *The International Style*.[1] This is the view of modern architecture which informed nearly every respected evaluation of the architecture of the later nineteenth and early twentieth centuries. This is the view which, therefore, must be apprehended and considered in any reexamination of architectural development from this period.

In the case of *The International Style* by Hitchcock and Johnson, what is most interesting and instructive is not only the extent to which they reflect and reinforce the already developing conventional view of modern architecture, but also, the extent to which they do not; that is, the extent to which their attitudes are American and not European. While it is evident that the young American authors of *The International Style* based their conception of a modern style on the example of European forms and theories, their discussion and organization of the issues was not always consistent with the European approach. Their assumptions regarding the significance of precedent and style and decoration were very un-European. Indeed, the very conception of a modern style was very un-European. These are the issues upon which they organized their essay and in this respect they explicitly reflected the contemporary American perspective on modern architecture and implicitly defined a style which addressed primarily American concerns.

In defining modern architecture in *The International Style*, Hitchcock and Johnson concentrated on appearance. They identified a discrete modern type characterized by skeletal construction, either steel or concrete, which allowed for wide spans of interior open space and exterior plate glass. This type, which began to emerge in Europe during the 1920s, persists as the conventional image of modern architecture. Among many of the early apologists of the modern movement, its development was conceded to be European. Indeed, as a type it was most effectively summarized in 1936 by Nikolaus Pevsner when he described Gropius's 1911 design for the Fagus Factory:

> A complete facade is conceived in glass. The supporting piers are reduced to narrow mullions of brick. The corners are left without any support [T]hanks to the large expanses of clear glass, the usual hard separation of exterior and interior is annihilated. Light and air can pass freely through the walls so that the closed-in space is no longer different in essence from the great universe of outside space.[2]

This type, which Hitchcock and Johnson singled out as the essential modern form, they perceived in the works of Walter Gropius, Le Corbusier, Mies van der Rohe and also in the works of several Americans both past and contemporary. They apprehended that this type, in its vertical form, was already particularly well-known to American architects as the skyscraper.

They clearly appreciated a visual affinity between the essential American architectural type and the essential modern architectural type; and they began to articulate the relationship between the American and the European developments in modern architecture. They began to discuss it, but they did not concentrate on the American skyscraper.[3]

The spare, skeletal type formed the basis for their articulation of the three "broad" and "fundamental" principles of the International Style:

> There is, first, a new conception of architecture as volume rather than as mass. Secondly, regularity, rather than axial symmetry serves as the chief means of ordering design. These two principles, with a third proscribing arbitrary applied decoration, mark the productions of the international style.[4]

The unadorned surface, which Hitchcock and Johnson perceived and endorsed as one of the fundamental principles of modern architecture was its most clearly visible attribute. However, it was also the most anomalous, since the equation of beauty with adornment in architecture was a deeply rooted concept going back centuries. But the unadorned surface revealed a new aesthetic for the new architecture, which renounced the traditional practice of applying decoration while it presumed that whatever was truly and simply fitting to its purpose was also beautiful. Walter Gropius himself described this effect:

> The New Architecture throws open its walls like curtains to admit a plenitude of fresh air, daylight and sunshine. Instead of anchoring buildings ponderously into the ground with massive foundations, it poises them lightly, but firmly upon the face of the earth; and bodies itself forth, not in stylistic imitation or ornamental frippery, but in those simple and sharply modelled designs which every part merges naturally into the comprehensive volume of the whole. Thus its aesthetic meets our material and psychological requirements alike.[5]

In Europe the unadorned surface also implied an ethical choice of utilitarian construction and social commitment[6] which led some European functionalists to deny their architecture any aesthetic association whatever. As Hitchcock and Johnson described them, these architects:

> Approach[ed] architecture from the materialistic point of view of sociology, went behind the problems that are offered to the architect and refused their sanction to those which demand a fully architectural solution. In their estimation the modern world has neither the time nor the money required to raise building to the level of architecture. Although they are usually ready to recognize and distinguish the aesthetically good and the aesthetically bad, they deny that such a distinction has significance at a time when the world has such positive need merely of good building.[7]

The aspects of social responsibility and aspirations inherent in European modernism, however, were never really appreciated or adopted in the United States. Hitchcock and Johnson simply excluded these aspects from their discussion, as Alfred H. Barr, Jr., the Director of the Museum of Modern Art, explained in the Preface to *The International Style*:

> It should be made clear that the aesthetic qualities of the Style are the principal concern of the authors of this book [Mr. Hitchcock] and Mr. Johnson have also made little attempt to present here the technical or sociological aspects of the style except in so far as they related to problems of design. They admit, of course, the extreme importance of these factors, which are often stressed in the criticism of modern architecture to the practical exclusion of problems of design.[8]

Hitchcock and Johnson were admittedly more interested in the *apparent* aesthetic qualities of the new architecture, qualities they defined as style. They were most interested in how a building looked. For them and for most Americans, morality in architecture still had its traditional meaning, which was based on the expression of beauty. It did not mean the power to reform society. Unlike the Europeans, Hitchcock and Johnson were seeking "a fully architectural solution." This distinction becomes clearer when one realizes that Hitchcock and Johnson maintained the traditional distinction between architecture and building. They described a "hierarchy of aesthetic significance"[9] Building, which they considered aesthetically neutral, was at one end. Moving toward the other end, they explained "the wider the opportunity for the architect within the limitations of structure and function to make judgments determined by his taste and not merely by economics, the more fully architectural will be the resultant construction."[10] Furthermore, there is a reproof implicit in their judgment that, "the European functionalists are primarily builders, and architects only unconsciously."[11] The notion of a hierarchy of aesthetics and the belief in the preeminence of the architect's design judgment are both attitudes often expressed in American architectural discussions. They are also attitudes which are consistent with the idea of style.

Although Hitchcock and Johnson affirmed the modern type of architecture based on functionalism and derived from skeleton construction, these American interpreters of the new forms also diverged from their European sources in their assumptions about the less tangible nature and background of modern architecture. Specifically, Hitchcock and Johnson placed modern architecture in a broad historical context, and they defined it as a style. The Europeans did neither.

The Europeans believed that modern architecture stood apart from the past as something unique and absolute. They rejected the past, especially the immediate past. For example, in the opening of his essay on the new

architecture, Walter Gropius wrote that "A breach has been made with the past, which allows us to envisage a new aspect of architecture."[12] It was the conviction of many, including the young advocates of modern architecture, that a new age, wholly unique in history, was unfolding and along with it a new spirit which would generate the new, the radical, the progressive and the unprecedented in every area of human endeavor. This modern consciousness became the leitmotif of Le Corbusier's commitment to a new architecture; "A great epoch has begun. There exists a new spirit,"[13] he wrote in the introduction to *Vers Une Architecture*. The greatness and certainly the uniqueness of the new epoch was believed to lie in its dynamic industrial and technological spirit. It seemed that for many contemporaries, "speed and the roar of machines"[14] epitomized the spirit of the age. Furthermore, it was a common belief, ironically inherited from the nineteenth century, that the spirit of an age should be embodied in the art and especially in the architecture of that age. Therefore, many were also led to believe that the only true architecture for the new age was one which was "fully expressive of the twentieth century,"[15] one "corresponding to the technical civilization we live in."[16] In this respect, the past, particularly the immediate past, was considered to be irrelevant and more seriously an "ethical" threat to the new age. To look to the past was to deny the essence of the new age, to stand against necessity and destiny: "The inevitable logical product of the intellectual, social, and technical conditions of our age."[17] From a European point of view, modern architecture could not compromise with the past. The breach had to be complete, particularly because the past had so blatantly relied on revived historical styles. "The [historical] 'styles,'" said Le Corbusier, "are a lie."[18] Because they believed that stylistic eclecticism, the mainstay of architectural practice just before the advent of modern architecture, either concealed or ignored or distorted the integral structure and function of modern buildings, the immediate past, immoral and dead, was to be repudiated in the new age.

Implicitly, Hitchcock and Johnson agreed that the new age demanded a new architecture; their clear preference for the European forms would confirm that. However, they did not repudiate the past. They gave both credence and value to the past. In fact, they believed that "a directed evolution,"[19] rather than a breach, had given rise to the new style. In order to clarify this, they distinguished three "histories" of architecture at work during the immediate past: first, the story of revivals and eclecticism; second, the introduction of structural innovations; and third, the influence of individualistic designers. Furthermore, they considered that each of these developments had a particular relevance for the "evolution" of the modern style.

The first history they considered was the past that the Europeans so thoroughly disavowed: "the conventional story of nineteenth century reviv-

als and eclecticism."[20] Hitchcock and Johnson, however, explained several valuable contributions of the revivals:

> Within the Classical Revival there developed a new sense of design, purer and more rational than that of the Renaissance or the Baroque Within the Medieval Revival there grew up a body of doctrine, based on the practice of the builders of the Middle Ages, which foreshadowed the theories of our own day
>
> The style of the twelfth and thirteenth century was the last before our own day to be created on the basis of a new type of construction
>
> As late as 1904 it was possible to conceive of modern architecture chiefly as a sort of renaissance of the Gothic.[21]

Indeed, the notion of a classical revival reiterating formal purity, while a Gothic revival reinforced structural integrity, was part of a prevalent American argument that intelligent eclecticism could and would give rise to an appropriate contemporary style. Such an apology for the historical styles was never made by the European modernists.

The second history which Hitchcock and Johnson identified was that of structural innovation. It is very interesting that they perceived the "development of new engineering methods of construction and the gradual replacement of traditional masonry structure by successive innovations"[22] as unfolding behind the facade of the revivals. It is likely that they were sensitive to that possibility, because the conflict between authoritative historical precedents and practical technological innovations, which often produced "but a decorative garment"[23] over essential structure, was particularly well defined in the United States, and at the heart of the stylistic dilemma which had bewildered American architects for several decades. Significantly, Hitchcock and Johnson alluded to this dilemma in the very beginning of their treatise:

> Out of . . . the difficulties of reconciling . . . revivalism with the new needs and the new methods of construction of the day grew the stylistic confusion of the last hundred years.[24]

That is not to say that they excused the confusion or even the dilemma. However, it was the American approach to understand and rationalize the dilemma rather than to reject past styles. The American perspective not only tolerated compromise, it believed that it was a necessary part of architectural development. This is made even clearer in Hitchcock and Johnson's reference to Hitchcock's earlier thesis of a "New Tradition" in architecture.[25] According to Hitchcock, the New Tradition was "*a sort of style* in which the greatest common denominator of the *various revivals was preserved* and *fused with* the *new science of building*."[26] The very notion of an acceptable compromise between the revivalistic styles and functional engineering was utterly un-European, but distinctively American.

Hitchcock and Johnson perceived a third history which they described as "the individualistic revolt"[27] of the "half moderns," those "who first broke consciously with the nominal discipline of the revivals."[28] Significantly, they named several American architects in this special group. In fact, they assert that "it was in America that the promise of a new style appeared first and, up to the [First World] War, advanced most rapidly."[29] Specifically, they recalled Henry Hobson Richardson who, they said, "often went as far as did the next generation of the Continent in simplification of design and in direct expression of structure."[30] Following Richardson, they noted John Root and Louis Sullivan who, "deduced from steel skyscraper construction principles which have been modified but not essentially changed by later generations."[31] Finally, they recognized Frank Lloyd Wright who, "introduced many innovations, particularly in domestic building His open planning broke the mold of the traditional house, to which Europe clung down to the War. He also was the first to conceive of architectural design in terms of planes existing freely in three dimensions rather than in terms of enclosed blocks."[32] On the other hand, Hitchcock and Johnson relegate these figures, including Wright, to the limbo of "half-moderns." "There is," they maintained, "a definite breach between Wright and the younger architects who created the contemporary style,"[33] and "there is a basic cleavage between the international style and the half-modern architecture of the beginning of the present century."[34]

It is important to understand that Hitchcock and Johnson rejected Wright as a complete modernist because of his persistent individualism. "One might regret," they explained, "the lack of continuity in his development and his unwillingness to absorb the innovations of his contemporaries and his juniors in Europe."[35] Indeed, a fundamental premise behind their recognition of a modern style was unity or coherence. And Hitchcock and Johnson believed that individualism undermined coherence. Many Europeans also eschewed individualism and a lack of unity, but they did so for somewhat different reasons.[36] The extreme value that Hitchcock and Johnson placed on unity was related to their American background. They had explained that the "individualistic revolt" was only half-modern because "[it] did not remove the implication that there was a possibility of choice between one aesthetic conception of design and another."[37] In other words, Richardson, Sullivan, Wright and the others did not create a single, unified style; they only added their own modes to the stylistic pool and increased the choice. In America, the impression that architecture embodied universal principles was important because ultimately Americans were searching for a single style. Yet, American architects were only dismayed, not demoralized by the stylistic proliferation. They continued to believe in a gradual process of development and to look forward to the eventual appearance of a single style which would appropriately express the modern American character.

Hitchcock and Johnson most definitely shared in the search for a style; it was the basic point of their treatise, as is made clear in its opening statement: "Since the middle of the eighteenth century there have been recurrent attempt to achieve and to impose a controlling style in architecture such as existed in the earlier epochs of the past."[38] They described no breach with the past, or in any way deplored this search for style. Rather, they affirmed it by invoking the authority of the past. Therefore, the outstanding attraction of modern architecture for them was that it concluded the search for style. They asserted: "The problem of establishing one dominant style, which the nineteenth century set itself in terms of alternative revivals, is coming to a solution Today a single new style has come into existence."[39] They perceived that the coherence of modern architecture, or its quality as a "controlling style," was its most salient characteristic:

> This contemporary style, which exists throughout the world, is unified and inclusive, not fragmented and contradictory In the last decade it has produced sufficient monuments of distinction to display its validity and its vitality.[40]

The entire introduction to *The International Style* is, in fact, an apology for "The Idea of Style," and is in striking contrast to the European view of modern architecture. Among the Europeans there was a persistent reluctance to refer to the new architecture as a style. They called it either a "movement," implying a sort of undeniable force, or simply "architecture" or "design," as if the modern form of these embodied, once and for all, their essence. The European aversion to the term can be explained, in part, by their association of style with the decorative pastiches which were applied to the surface of architecture by many of the conventional architects of the immediate past. In addition, however, the Europeans had developed deep ethical convictions and functional theories in reaction to the "style" oriented practices of the past, which if not always explicitly defined did give to modern architecture an impression of moral integrity.

Hitchcock and Johnson readily acknowledged that the idea of style had lost a great deal of its credibility due to a superficial understanding and practice of it. On the other hand, they argued that, with the advent of the new architecture, style had become "real and fertile again."[41] This was so because, they maintained, "Architecture is always a set of actual monuments, not a vague corpus of theory."[42] They defined, therefore, a set of particular visual characteristics and promised that, "anyone who follows the rules . . . can produce buildings which are at least aesthetically sound,"[43] Their interpretation of modern architecture as style meant, essentially, a concentration on the exterior manifestations of the architectural productions, and it resulted in an explication of specific forms, practices and images which could be, in effect, methodically reproduced without a com-

mensurate commitment to theory. In any case, the interpretation of architecture as style was an inherent aspect of the American perspective.

Hitchcock and Johnson confirm an American development of modern consciousness and aspiration. Their references to the search for style, the attempt to reconcile precedent and progress, the tolerance for revivals and eclecticism, the "half-moderns," the steel-framed skyscraper, are all drawn from the American experience and are all indicative of a particular American "evolution" toward a modern style. It is not then surprising that in 1932, when *The International Style* was published, American architecture was dominated by an eclecticism which had been broadened to accommodate modernism but was, nevertheless, still in search of a conclusive style. The influence and prestige of *The International Style* has always been based on the acute perception and incisive analysis of the European forms of modern architecture by its young American authors. Equally significant, however, although less immediately apparent, *The International Style* is also an expression of the unique American perspective on modern architecture, and of the moment when American architects were most prepared to accept European modernism.

3

The Search for Style

Why should we not have one characteristic style, expressing the spirit of our own life?

Thomas Hastings, 1894

In 1900, architect Ernest Flagg lamented, "At no time has there been anything which might properly be called an American style of architecture."[1] Flagg and other architects, such as Thomas Hastings, articulated the prevalent dismay at the lack of an appropriate architectural expression of what contemporaries considered the unique American civilization. American architects at the turn of he century firmly believed that "architecture . . . images at all times a nation's character"[2] and that every great nation and civilization had developed a characteristic architecture. They were, therefore, troubled by the lack of an "American" style. Moreover, based on their beliefs, the apparent lack of a national style implied that there were serious faults in the American character which precluded the development of properly American architecture. Hence, the desire for a national style was coupled with the struggle of Americans to overcome a sense of cultural inferiority. Indeed, so potent was the desire for an American style that it lasted well beyond the generation of Hastings and Flagg and continued to affect the most significant architectural judgments throughout the period between 1893 and 1933. For example, in 1905, the search for a proper style induced architect Frederick Lamb to propose "the modern use of the Gothic" on skyscrapers as the basis for "the possible development of a future architectural style."[3] And, in 1916, architectural historian A.D.F. Hamlin concluded a review of twenty-five years of "modern American architecture" with a reassuring confirmation of its "American-ness": "underneath the eclectic details and through them all, one may discern the real American architecture — American in planning, construction, and material; in conception and in spirit American, and nothing else."[4] Evaluating the impact of the 1922 Chicago Tribune Competition, one critic prophesied "a really distinctive, a truly American, Architecture."[5] Lewis Mumford, in 1924, also dis-

cussed the issue of "a genuine modern American architecture," but complained that critics sought evidence for it only in the skyscraper.[6] Then, in 1932 Hitchcock and Johnson announced that, "Today a single new style has come into existence."[7] And finally, in 1933 the chairman of the Architectural Commission coordinating design for "A Century of Progress" Exposition in Chicago declared that, "The Fair stands as a symbol of the architecture of the future" because it was a "very modern expression of architectural ideas."[8] Examples of attitudes such as these suggest that the search for an appropriate modern American style was the essential issue underlying the architectural discussions of this whole period.

The expectation that America should develop a characteristic architecture ran especially high in the last decade of the nineteenth century. It was a significant part of the reason why the architecture at the World's Columbian Exposition in Chicago in 1893 was so enthusiastically received. In the view of contemporaries, the architectural effect of this Fair was unprecedented in this country for its magnificence, aesthetic quality and consistency: "a dream city that for beauty and consistency and true art has never been equalled or approached before or since that Exposition."[9] Many concluded that the Fair marked America's architectural coming of age,[10] at the same time that it ushered in a cultural renaissance.

This impact was all the greater because in 1890, three years before the opening of the Chicago Fair, the prevailing assessment of the state of American architecture was almost without exception condemnatory.[11] Most observers deplored the chaotic state of the art, dominated as it was, in their view, by a polyphony of styles, most of them based on medieval sources and most of them undisciplined. The architect Robert Peabody put it this way: "We have doubtless seen a great deal of ostentation and vulgarity built into more or less permanent form, and doubtless we are very far from having produced great works of architecture."[12] Another observer contended, "architecture in the United States, both civil and domestic, is in general either copied directly from European models, or is a promiscuous commingling of different styles selected from various models."[13] Conscientious observers were offended, dissatisfied and distressed by the unprincipled eclecticism which they saw creating a deplorably inadequate body of architecture. However, the most bewildering aspect of the situation was, for them, the lack of an American style. As one writer expressed his dismay: "To a stranger it seems incompatible that we, who have nationalized almost every other branch of art, should have so completely neglected this very important one."[14]

Moreover, the degree to which contemporaries believed that architecture expressed the nation's unique character and genius and embodied its achievement and greatness cannot be overestimated. This belief was implicit in deeply rooted nineteenth-century historicist attitudes and elicited a gen-

eral conviction that "the particular genius of any given race or any given period incarnates, as it were, in some architectural construction characteristic, and therefore symbolic of it."[15] An important corollary to the historicist attitude was the belief that every great civilization has inevitably produced a characteristic and valuable architecture. Everyone agreed that this was supported by the historical record. As architect Thomas Hastings explained:

> The important and indisputable fact is not generally realized that from prehistoric times until now each age has built in only one style of architecture. In each successive style there has always been the distinctive spirit of the contemporaneous life from which its roots drew nourishment.[16]

"But in our time," sadly observed Hastings, "contrary to all historic precedent, there is a confusing variety of styles."[17] Contemporaries were convinced that the failure to produce a great architectural style was of the most profound significance.

The architectural literature of the period confirms that the search for a proper American style was intensely frustrating. The stature of America's economic, political, even international prestige was increasing rapidly, yet her architecture appeared to be in an embarrassing state. It seemed as if the spirit of American life had disdained her architects. It is not difficult to appreciate that any indication that the situation had changed for the better would receive a great deal of attention. Those concerned would be eager for some cessation of the "confusion of styles which afflicts us in this country,"[18] as they would also be eager to be impressed with a sign that national greatness was at last mirrored in architectural form. One might even say that they needed to be impressed. A most significant cause, therefore, for the success of the World's Columbian Exposition was that it satisfied this need to see American culture and genius reflected in architecture.

Months before the Fair officially opened its gates, people were already encouraged to be impressed. Several articles appeared in the popular press, as in, for example, the pages of *Harper's Magazine*:

> There is a growing belief that the exposition will not fail from an artistic point of view. The broad and liberal spirit which led its projectors to seek the aid of the most distinguished architects of the country is reassuring to those who have doubted whether our fair would vindicate American taste at the same time that it would display our wealth and progress.[19]

The Fair itself more than fulfilled expectations. Most critics were effusive, even extravagant, in their praise:

> This Fair of ours, in its general aspect and judged from the artistic point of view, is not only much more successful than two years ago, we believed it could be; it is much more

successful than any that has ever been created in this or another land. It is not only comparable to the beautiful Paris Exhibition of 1889, and not only equal to it; it is greatly superior.[20]

The reasons for this enthusiastic response were directly related to the fact that the Fair relieved most of the prevailing anxieties about the state of American architecture. The critic Montgomery Schuyler astutely identified the impression of stylistic unity as the ultimate reason for the success of the Fair's architecture. He explained that its success was, "first of all, a success of unity."[21] The choice of the classically based Renaissance styles allowed the promoters to create a magnificent vision (figs. 3 and 4) which provided a single coherent style capable of expressing monumentality, dignity, and cultured taste, all qualities which were believed undermined by the undisciplined proliferation of styles before the Fair.

Others, such as novelist William Dean Howells, realized that the dignity and discipline of the Renaissance style could serve as a much needed model for reform of the past excesses in American architecture. Addressing his audience in 1893 in the guise of a traveler from the imaginative utopia of Altruria[22] Howells looked forward to the beneficial effect of such a good example:

> Now what they needed was some standard of taste, and this was what the Fair City would give them. He thought that it would at once have a great influence upon architecture, and sober and refine the artists who were to house the people; and that one might expect to see everywhere a return to the simplicity and beauty of the classic forms, after so much mere wandering and maundering in the design, without authority or authenticity.[23]

Architect and critic Henry Van Brunt, who himself was directly involved in the Fair,[24] was even more specific about his hopes for the reforming effects of the Fair on the subsequent development of American architecture. When he observed, "It is sufficiently evident that to architecture, at least, the Exposition will bring a message of civilization which cannot be misunderstood,"[25] he was referring to an "impulse for reform, and for a greater unity of effort in the establishment of style,"[26] and not to a wholesale adaptation of the Renaissance style. Van Brunt considered the "classic" motifs of the Court of Honor as an "object lesson"[27] useful in order to "elevate and purify our ideal, and to correct the inevitable tendency of the modern mind to wander in regions of unprofitable invention."[28] He would welcome the "classic" as a disciplinary corrective, "a revelation of the possibilities of architectural composition in pure style,"[29] and an admonishment that "true architecture cannot be based on undisciplined invention, illiterate originality, or, indeed, upon an audacity of ignorance."[30]

On the other hand, Van Brunt was sensitive to the lack of a coherent national style and he did not welcome a new revival, "however successful it

may prove to be in execution."[31] He remained convinced, as did the majority of his contemporaries, that ultimately the development of a truly indigenous American style was a matter of evolution involving several factors, including the lesson of classical discipline and formalism; however, this was not inconsistent with the notion of a unique or wholly American style. At the turn of the century, style was conceived of as the particular elaborated appearance of a building, which in turn was assumed to be based on traditional styles. Style was equated with aesthetic quality and beauty itself was conventionally defined as embellishment, preferably derived from approbated historical sources. Therefore, it was originally assumed that the American style would develop in accordance with precedent and not in defiance of it.

Others, however, like Van Rensselaer, in the intensity of their enthusiasm and relief, rushed headlong into the conclusion that this coherent style was the most appropriate for the time, even to the extent of calling it modern:

> I think . . . that intelligent observers will feel that for the chief group of buildings the best possible architectural scheme was chosen. No other styles could have served so well as these allied yet not identical Renaissance styles in giving the architects a chance to build in agreement with each other and yet to meet special practical needs and express individual tastes. The essential dignity, the truly modern spirit, and the practical as well as aesthetic elasticity of Renaissance architecture will be convincingly displayed
>
> The aspect ought to prove that Renaissance forms of art are the best for current use And I think the Fair, by bringing Renaissance art into popular favor, will thus do the country a very valuable service.[32]

She even hints that the choice of Renaissance style was in some way functionally appropriate, if one accepts the notion that expression or symbolism is a function of architecture. Indeed, Van Brunt agreed on this point when he described the choice of style for the architecture of the Court of Honor at the Fair:

> In the entire absence of any distinctively American style capable of giving adequate expression to our position in history, it was evident that the great court wherein the guests of the nation were to be received, and where they should be welcomed with stately ceremony, should be surrounded by buildings of a style most associated with modern civilization, a style so organized and accepted that personal fancy or caprice should have the smallest possible scope in it. It was therefore, decided that the work should be in classic as pure as our scholarship could command, and on a scale commensurate with the intention of our hospitality.[33]

Everyone agreed that the architecture of the Fair was enormously significant, especially insofar as it brought an end to the proliferation of ill-conceived styles. Many could conclude, with good reason, that the example

of the Renaissance styles addressed the most serious omissions in contemporary American architecture. These styles exemplified dignity and unity together with practical and aesthetic elasticity, as Van Rensselaer suggested. Moreover, within the conventional understanding of style as derived from historical precedent, the Fair also expressed the spirit of the great imperialistic expansion and genteel tradition that dominated turn-of-the-century America.

On the other hand, however awed they were initially, most considerate observers did not consider the Fair a final solution for very long. Like Van Brunt, they viewed the example of the Fair as a significant and welcome phase in the continuing development of an American style. Furthermore, the architectural example of the Fair proved to be irrelevant to the other major architectural concern of the period: the proper stylistic treatment of the steel-framed tall building. Contemporaries were forced to acknowledge, usually reluctantly, that a stylistic treatment that could not be accommodated to the steel-framed tall building would not express the fullness of the American genius.

American architects never forsook the architectural challenges of innovative materials and new requirements, even after the stunning affirmation of historical precedent at the Fair. Indeed, in 1898 the conservative critic Russell Sturgis concluded that "in very many designs . . . the old styles simply do not apply to us, and we are compelled to disregard them."[34] Specifically, he found:

> Many modern requirements are absolutely opposed to the pursuit of design according to the old principles. Many modern materials and methods of building, important and not to be disregarded, compel the introduction of new forms and new combinations.[35]

He was persuaded toward this foresighted conclusion by the design requirements of the tall building.

The unprecedented tall building developed at the same time that American architects were anxious for some sense of coherency and national prestige and identity in their architecture. However, a striking paradox between precedent and progress resulted from the different design approaches evoked by each situation. On the one hand, the historically based style of the Columbian Exposition provided an excellent example of dignity and formal discipline in which "correctness" could be substantiated through precedent. On the other hand, the tall building defied tradition. Its structural system was recognized as completely unprecedented, consisting as it did of a self-supporting cage made up of steel members which essentially rendered the load-bearing masonry wall obsolete. In addition, its materials, exaggerated height and commercial function were unexampled in past monumental architecture.

From its inception, the tall building was the focus of architectural

attention in this country. However anomalous it first appeared, the structural system was quickly appreciated as a major innovation. One critic called it "the most stupendous [structural] creation since Brunelleschi's dome."[36] Furthermore, it was considered a wholly American invention. Critics called it "America's chief contribution to the world's architecture,"[37] "the only indigenous architectural product to which we can lay claim."[38] A prominent architectural historian, George Edgell, wrote in 1928:

> It represents probably the most interesting phase of American architecture and certainly the most truly national. It was developed in this country, and nothing like it exists abroad. It was the result of American invention, American daring, and American engineering skill, and it expresses in the most modern way the American genius in architecture.[39]

Given the general belief that architecture embodied the national character, it is not surprising that critic H. Harold Kent, for example, found "the office building of steel with its innumerable stories soaring heavenward, [to be] the most appropriate expression of the noble aspirations and high ideals of the great nation which gave birth to it."[40] Even those who did not deem it noble believed that the skyscraper symbolized the nation's spirit. Architect-critic Claude Bragdon wrote in 1909:

> These many storied temples to Mammon . . . are the supreme manifestation of our need and our power to build, — to build on a gigantic scale, and in an unprecedented manner; and that, say what one may, is architecture — or architecture rampant it may be, but at all events alive.[41]

Few would argue with the assessment that the tall building had become the source of America's "most important monuments."[42] For the most part, American architects were extremely proud of their invention and enthusiastic about its dynamic qualities, which they closely associated with the American character. Architect Harvey Corbett found it "so daring, so virile that there is nothing else like it in the world. It stands unique among edifices."[43] Americans simply expected it to be the catalyst in the development of an American style.

Moreover, the tall building and its steel-framed construction were quickly associated with the technological aspects of modernism. Sturgis spoke specifically of modern requirements, materials and methods that required new forms and distinguished them from traditional requirements, materials and methods. Indeed, the article in which he stated his views was appropriately entitled, "Good Things in Modern Architecture." Henry Van Brunt was particularly perceptive about characteristics of the skyscraper that later became commonly associated with the modern movement; he noted "its hospitality to new materials and new methods of construction, its

perfect willingness to attempt to confer architectural character upon the science of the engineer, and to adapt itself without prejudice to the exactions of practical use and occupation."[44] In a very short period of time the steel-framed commercial building became a popular symbol of modernism in this country.

The debate provoked by the tall building and its unprecedented elements reached the highest levels of the profession. For example, in 1893, Henry Van Brunt addressed his colleagues in the American Institute of Architects on the very subject of "The Growth of Characteristic Architectural Style in the United States." He cited the tall commercial building as one of the most significant current facets of the problem and indicated that its particular innovations were among "the most distinctive characteristic[s] of our best work in architecture."[45] In addition, in 1896, the Thirtieth Annual Convention of the American Institute of Architects devoted an entire symposium to the topic, "The Influence of Steel Construction and of Plate Glass upon the Development of Modern Style."[46] Four papers were presented at this symposium. Among the presenters were Dankmar Adler of the Chicago firm of Adler and Sullivan and a lesser known but eloquent proponent of steel and glass as architectural materials, the architect J.W. Yost.

Both Adler and Yost were outspoken supporters of the new form and its associated materials. Both addressed the central issue of the debate which was the inability of architects to accomplish a fitting design for this new type based on precedent. Playing upon a dictum coined several months earlier by his partner Louis Sullivan,[47] Adler disavowed current architectural thinking as "founded upon the principle, 'form follows historic precedent,' which stamps as barbaric every structure for which the architect has failed to provide an academically and historically correct mask and costume."[48] Adler, who advocated Sullivan's original aesthetic in defiance of current practice, put his case this way:

What I have written is intended to be a protest against the dogma that Art in Architecture ended with the Renaissance, a denial of the assumption that the use of materials and processes and wants and functions unknown to the Masters who flourished in that glorious period or to their predecessors in other eras of great artistic vigor in architecture is incompatible with the performance of truly artistic work.

I wish to maintain that the steel pillar and beam and other contemporary contributions to the materials and processes of building construction, that the modern business building, and many other so-called monstrosities, are . . . legitimate contributions to architectural art

The new materials and processes, the new requirements, should not, however, in their introduction into architecture and in their assimilation by our art, be treated as things apart and by themselves, but as related to and part of all that has gone before in the long history of human and artistic progress.[49]

Adler, who trained as an engineer,[50] spoke for the western architects who were strongly influenced by the nineteenth-century rationalist and function-alist theories of Viollet-le-Duc and Gottfried Semper.[51] He championed an original, organically derived design for the tall building such as that for which his partner, Louis Sullivan, was becoming known. Furthermore, he challenged the conventional prejudices of traditionally trained architects against unprecedented materials and what they considered nonmonumental building types.

Yost, on the other hand, came close to advocating the unmitigated expression of the steel structure itself, that is, the "naked" cage:

> The fact is that the problem of a design in steel and plate glass for a tall building, is a new one, and it cannot be solved by the old rules There is no use trying to conceal the fact that what we see is only covering of the real building material, on whose efficiency the structure depends. There is no use trying to hold longer to the antiquated notion that only comparatively low buildings are Architecturally creditable. There is no use either, of our entertaining the idea that because steel cannot be successfully used in proportions suitable to stone, that, therefore, steel is not a good material for Architectural purposes. It seems to me, that while the steel must be concealed from the elements, it should not be concealed in the design, and that the surface of the building should take the form of a covering of continuous posts and a covering of horizontal members between posts, and the filling in the panels that intervene. It would seem also, that none of these three should be so designed as to make believe that it is the support of the structure, but the covering of posts and lintels should show that it is a covering, and a covering only, of that which is the support of all.[52]

Yost was extreme, but not alone, in proposing to express completely the steel-framed construction of these modern buildings. In fact, at this time, the profession generally recognized the unsuitability of the traditional styles for tall buildings. In an extensive article concerning the design prob-lems of the tall buildings, professor of architecture Barr Ferrée[53] shared Sturgis's conclusion: "The high building, being a new thing under the sun, no past style can give any help."[54] The alternative, as suggested by Adler, Yost and Sturgis, was to develop "new styles."[55] However, this was easier said than done, and it raised some serious questions, particularly concern-ing the aesthetic quality of such new styles.

At the same time that Sturgis avowed that American architects would be compelled to develop new styles to meet modern requirements and mate-rials, he doubted whether "they may or may not be valuable as a matter of fine art."[56] This was the core of the dilemma to be resolved in the evolution of modern architecture in America. That is, it was believed that the most modern and the most American architectural forms could not be success-fully treated with traditional methods or details; but any new treatment which derived from essential elements and not from precedent could not be considered beautiful.

Initially, three essential aspects of the tall building were thought to prevent it from being an aesthetic object: first, its unusual proportions; second, the structure of the building, that is, the metal materials and the unprecedented cagelike configuration; and third, the commercial function, which placed it quite low on the traditional hierarchy of building types.

Rarely had entire buildings been so predominantly vertical, and the extreme height of these buildings was considered an aesthetic anomaly. As Ferrée explained:

> Not since man began to pile one stone upon another has so difficult a problem been offered to the architect as the design of a high building. There is nothing more difficult than the artistic treatment of an object that has but one direction or in which one direction predominates over all others
>
> One may search the history of architecture from the most ancient times to the most recent without finding so much as a hint of the form.[57]

Indeed, indications of Ferrée's judgment can be seen in any number of early tall buildings, with and without steel frame construction, which essentially were treated as if they were stacks of lower, horizontal buildings separated by heavy, projecting cornices.

However, the most serious drawback to beautiful design seemed to be the new structural system itself. Once again, Ferrée expressed the general attitude of the profession:

> Of the many fallacies anent the high building and its art that enjoy a sort of vogue in good circles, none is more absurd than the notion that, because it is a skeleton construction, because its weight is carried on steel framework, and the walls and piers are only curtains or external inclosures of the inner frame, that does the work, therefore the design must express this construction in order to be truthful [I]t is a most preposterous idea, yet one that has a large support. No one would contend that mankind would look better were its skeleton of bone placed outside the flesh instead of within it; yet this is very much the proposition that construction-designers are maintaining.[58]

Ferrée did not believe that exposed metal skeleton construction, such as Yost advocated, could be beautiful. Furthermore, he alluded to a paradox which further complicated the design dilemma. To express the structure would be "truthful" and in keeping with one of the fundamental bases of architecture, that is, that it is an aesthetic expression of construction; but, to express this structure was at the same time to be unaesthetic. Moreover, as Ferrée admitted, although "preposterous," this idea of expressing the skeleton has "large support" "even in good circles," for reasons of architectonic integrity.

The depth of this aesthetic dilemma for American architects can best be understood from the ambivalent, albeit perceptive assessments of tall building design by Montgomery Schuyler, the most outstanding American archi-

tectural critic of the late nineteenth century.[59] Schuyler was among the first to call general attention to the treatment of commercial buildings in Chicago, in a series of articles published in *Harper's Magazine* in 1891.[60] He was originally impressed by the austere and utilitarian treatment of tall commercial, or "elevator" buildings as he called them, in Chicago. In 1894, he summarized his opinion concerning the implications of this type of building in an article significantly entitled "Modern Architecture," for the *Architectural Record*:

> By the introduction of the elevator, some twenty years ago, an architectural problem absolutely new was imposed upon the American architects, a problem in the solution of which there were no directly available and no directly applicable precedents in the history of the world. That many mistakes should be made, and that much wild work should be done was inevitable. But within these twenty years there has been attained not only a practical but in great part an artistic solution of this problem presented by the modern office building. The efforts of the architects have already resulted in a new architectural type, which in its main outlines imposes itself, by force of merit, upon future designers and upon which future designers can but execute variations. This is really a very considerable achievement, this unique contribution of American architects to their art.[61]

Interestingly, while Schuyler acknowledged the lack of precedent, he did not consider it an insurmountable stumbling block. However, he balked at the anomaly presented by the construction:

> But the problem is by no means yet completely solved. The real structure of these towering buildings, the "Chicago construction," is a structure of steel and baked clay, and when we look for an architectural expression of it, or for an attempt at an architectural expression of it, we look in vain.[62]

In fact, when he referred to an "artistic" solution to the design problem or the "architectural expression" of the "elevator building" he did not mean a direct expression of its structure. Although Schuyler was ahead of many of his contemporaries in broadening architectural principles restricted by historical precedent, he never accepted, or could never accept, the full implications of a modern functional aesthetic. His assessments of two Chicago elevator buildings, the Monadnock Block and the Reliance Building, illustrate this most clearly. The Monadnock Block (fig. 5), designed in 1890 by John Root in partnership with Daniel Burnham, impressed Schuyler "as precisely the most effective and successful of the commercial structures to which the elevator ha[d] literally 'given rise'."[63] He makes it clear that his assessment has nothing to do with skeleton frames:

> It is probably well for the architecture of the Monadnock that it was built before the Chicago construction was developed. In the buildings in which that construction is really followed, and the wall omitted, even at at the base, the highest success that has thus far been attained amounts rather to a statement of the problem than to a solution of it.[64]

Significantly, the elements which produced the impressive and expressive quality of this austere building for Schuyler were a "series of subtle refinements and nuances"[65] of the massive masonry wall. Schuyler was eloquent on this point:

> The original Monadnock has the great advantage . . . that the walls are real walls that carry themselves, and that may properly be thickened at the base. But this thickening at the base, or rather this thinning of the wall as it rises is not only very subtly and skillfully done in the Monadnock, but it is only one of many refinements
>
> So far from being crude, as the absence of ornament might lead a hasty observer to conclude, the design of the Monadnock . . . is of an extreme refinement, and the impressiveness of it due to the subtlety of the devices that have been employed to mitigate the asperities and bring out the possibilities of expression in a brick box of sixteen stories.[66]

On the other hand, Schuyler's assessment of the Reliance Building (figs. 6 and 7), designed by Charles Atwood between 1893 and 1894,[67] in which the supporting steel frame is blatantly expressed, is at best ambivalent:

> The frankness of the treatment is complete. The covering is confessedly a covering and does not in the least simulate a structure nor dissemble the real structure. The designer has not allowed himself a base, though he has indulged himself in a pretty and becoming attic. If he says, as he seems to say, that this is the actual sky-scraper, the thing itself, and that any attempt to do more than he has done is to deny the essential condition of the problem, it must be owned that he has a good deal to say for himself But on the other hand, it must be owned that if this is the most and best that can be done with the sky-scraper, the sky-scraper is architecturally intractable; and that is a confession one is loth to make about any system of construction that is mechanically sound.[68]

Schuyler's skepticism concerning the successful architectural modulation of the innovative skeleton frame is undeniable. He considered the Monadnock, not in spite of, but because of its traditional construction, to be the superior tall building, especially when viewed aesthetically. As Schuyler concluded, "Certainly a comparison between the Reliance and the Monadnock is overwhelmingly in favor of the older building."[69] "Indeed," he continued, "we must own that Chicago construction in its latest development, has not yet found its artistic expression, that no designer has yet learned to deal successfully with a structural change so radical that it has abolished the wall."[70] On the other hand, the unique qualities of the Reliance Building drew more than Schuyler's perceptive attention. Indeed, it is an indication of the considerable interest generated in the profession by steel-framed tall buildings, even "architecturally intractable" ones, that the Reliance Building merited a review in the *Architectural Record*. Significantly, the reviewer focused on the material and structural innovations,[71] but denigrated the aesthetic possibilities:

The somewhat limited ground space and the great height of the building present difficult problems to the architect who attempts to produce an attractive structure, and with its plate-glass foundations, which the shopkeeper demands, it is hardly to be supposed that even the designer will consider it a masterpiece.[72]

In short, however credible they considered the technical innovations of skeleton construction, or however seriously they considered the argument for an honest treatment of structure, Schuyler and most of his generation, given their training, found it almost impossible to see the plain skeleton frame as beautiful. To paraphrase Schuyler, they found it difficult to abolish the wall.

Indeed, Montgomery Schuyler found that he could not suggest a better solution for the design of the steel-framed building than to "give the cage a solid base and an enriched top, and to leave the interval as a cage,"[73] nor a better example of this treatment than the Wainwright Building in St. Louis (fig. 8) designed by Louis Sullivan. This tripartite scheme articulated by Sullivan[74] allowed the Wainwright, as Schuyler pointed out, "to present a sensible diminution of massiveness as it rises."[75] The basement of the Wainwright, noted Schuyler, was in brownstone, a substantial weight-bearing material. Above the base, "in the superstructure," he approved, "the skeleton, the cage, is confessed, . . . although the envelope is of brickwork."[76] In fact, the tripartite system as Schuyler analyzed it provided for a compromise between skeleton and masonry, giving the base over to massiveness and allowing the lighter upper part of the building to express the skeleton frame honestly.

On the other hand, Schuyler also paid close attention to the decoration of the Wainwright:

The decoration [of the panels filling the spaces between sills and floor-lines] not only promotes the understanding that they are insertions extraneous to the stark structure, but also defers to the material That the decoration is effective by design and by scale need scarcely be said. The real enrichment of the structure, however, is in the cornice and the cornice-story, where it forms an appropriate crown and here the richness, intricacy and refinement of the ornament amount to a signature.[77]

The question of whether embellishment was appropriate was another significant aspect of the problem of an aesthetic treatment for the tall building. In an age when architectural beauty was equated with the traditional styles and especially with their decorative details, and the glorification of profit was still considered vulgar and an unsuitable motive for aesthetic expression, the use of decorative details, at first, was deemed inappropriate for commercial buildings.

The high building, like many other modern structures, is not built with the idea of erecting a beautiful or artistic edifice. First, last, and all the time it is a commercial

building, erected under commercial impulses, answering to commercial needs, and fulfilling a commercial purpose in supplying its owner with a definite income.[78]

For example, Ferrée accepted the severity of the Monadnock because austerity was appropriate for commercial structures. He called the design "monotonous,"[79] explaining:

> The conditions of the building have . . . [to be] understood. It is of unusual height, and its longest side is of unusual width; it is intended solely for commercial purposes; it is not a monument devoted to artistic ends. It would not have made it a better building for its purpose to have strewn its front with columns and entablatures, or to have spread decorations around its windows; on the contrary, these things would mean an added utility. In this building, as in all high buildings, it is not what should be that is to be considered, but what is.[80]

However, Louis Sullivan, whose work was more closely associated with the tall building than that of any other architect, never designed a "naked" skyscraper. Within the decade after the Fair, when Sullivan completed his most important designs,[81] the tall building had proliferated rapidly in number, height and conspicuous display.[82] Moreover, as it grew taller, its potential for conspicuous display grew greater. As a result, the most modern and the most American architectural innovation also became the most prestigious building type in America. The earlier distinctions between the aesthetic and the utilitarian, between the monumental and the commercial, between architecture and building, which had initially troubled designers were swept away by the enormous prestige accorded to the tall building. By nineteenth-century standards, no building form with such impact could be left without an aesthetic treatment, that is, without embellishment. Even Ferrée had come full circle by 1904 to declare, the change toward "simplicity in design [of the high building] . . . is quite for the worst But, lack of interest is altogether inexcusable."[83] Ferrée also found himself saying, ten years after his first analysis of the tall building, "the most impressive element in the high building is its height."[84] Indeed, Ferrée felt that Louis Sullivan was the most successful at expressing the vertical essence of the high building.[85]

The fact is that, in the decade after the Fair, Sullivan's reputation grew. He secured commissions for important office buildings in the growing centers of the Midwest, but also in New York City. The tripartite scheme for the design of the tall building which had been articulated by Sullivan and which was commonly ascribed to him, was the basic formula for tall building design by 1904. Ferrée, not a Sullivan devotee, acknowledged the general opinion that "[he] has long been our most conspicuously individual practitioner."[86]

Another critic, reviewing his design for the Schlesinger-Mayer Depart-

ment Store[87] in Chicago, called Sullivan "our only Modernist," because "there is not a vestige of the past in Sullivan's work. It is as modern as the calendar itself."[88] Sullivan's most conspicuous characteristic was his originality, equated at this point with modernism. His contemporaries singled out two aspects of that originality which were of particular interest to them. First, were the original decorative schemes which he developed and which were noted by Schuyler. Contemporaries were very specific in noting and appreciating that Sullivan's decoration never appeared to be based on the historical styles. On the other hand, Sullivan's reputation for originality and individualism was also related to the rationalistic expression of structure in his designs. The critic of the Schlesinger-Mayer Store noted that Sullivan was the only architect actually meeting the "new problems in design that really demand by the obvious logic of structure and function, the development of new architectural formulae."[89] In fact, Russell Sturgis, who earlier also called for new forms and combinations and styles to meet the modern requirements, singled out Sullivan's Bayard Building of 1897–98 in New York City as a significant example of the "constructional sincerity and . . . rational design."[90] The example of this building, he felt, would generally benefit American architecture:

> There is . . . no pretense that the building is a massive structure of cut-stone, and no pretense that it allows of treatment in the modern classical way with orders and classical proportion. The whole form is a careful thinking-out of the problem, How to base a design upon the necessary construction in slender metal uprights and ties Here the metal construction is covered and completely enclosed in tile and brick and the whole facade consists of a series of slender uprights running from top to bottom and consisting of the actual construction piers where steel columns are jacketed by baked clay laid in mortar and, alternately, slender mullions built in the same way, but without constructional value.[91]

Sturgis, however, was prepared now to dismiss Sullivan's elaborate arches and tracery. Without its somewhat "irrational" decorative indulgence, Sturgis predicted that the Bayard would prove to be "the architectural treatment of the future metal building of our cities in the form which it must pass through if it is to reach any serious architectural success."[92]

Not only structural rationalism, but also functional rationalism was ascribed to Sullivan during this period. Another critic of the Schlesinger-Mayer Store commented:

> the function is unmistakably expressed in the design The design is thoroughly modern. It shows fully the structural function of the steel frame with the enclosing protection of terra-cotta This is frankly a department store Hence, throughout its typical floors, the window openings are of maximum size and form a distinct basis of the exterior design.[93]

Sullivan's reputation after the Fair was impressive because of the dimensions he added to the search for a proper treatment of the steel-framed tall building. Sullivan incorporated a response to structure, function and decoration in his treatment of the style. Moreover, those dimensions were a significant reflection of the general concerns related to the tall building which continued to be debated for years to come. Sullivan's personal influence, however, waned after 1905. This occurred for several reasons. First of all, traditionally trained architects remained convinced that the frankly expressed steel-frame could not be beautiful. Second, the tall building had attained a status which made use of the preferred, historically based monumental styles seem appropriate, and many prominent architects gladly returned to them. Henry Van Brunt articulated the reasons for their continued reluctance to abandon historical styles for the skyscraper:

> It is the natural impulse of the man of education to protest against any innovations which cannot be clothed in those accepted forms of beauty and grace which have become venerable from long usage and from association with the greatest triumphs of art in history. The artist does not readily abandon his ideals; no inspired mechanic or learned engineer will ever appear to overthrow them. The artist alone is now responsible for the present condition of architecture in this country. It is not his disposition to make changes for the sake of change, and he can never forget the historical styles and all that has been done in the past.[94]

What has often been interpreted as an irrational reactionist view must now be understood as a valid reflection of contemporary values of professionalism and aesthetics, both important factors in the development of modern American architecture.

Finally, Sullivan's work was too original. His influence waned because, even in the opinion of a favorable critic, "to say that he has invented a style would . . . be to say too much."[95] It was a basic assumption of the period that original work could never form the basis of a lasting, coherent style. Russell Sturgis was against originality because he considered it forced or self-serving: "Let it be admitted once and for all that our constant demand for originality has something unreasonable about it."[96] "The true system of architectural design . . . ," he felt, was "not to ask for originality but to build on the lines laid down by one's predecessors and let originality come if it will."[97] Two chroniclers of the work of McKim, Mead and White asserted, "It should be clearly understood and loudly proclaimed that the less American architects worship at the altar of Individuality, the better it will be for American architecture."[98] They argued that architecture "is essentially a social art, in which the best results can only be obtained by cooperation"[99] and that individualism was a deterrent to the natural evolution of quality architecture.

> The transition from a low to a higher stage of architectural development is never the result of a revolution. It must be brought about by the slow accretion of small improve-

ments, and the part that any one man can play in the process is never the part of a "star" performer.100

Although the most thoughtful observers of the period considered Sullivan's experiments valuable, even compelling, most continued to also hold firmly to the judgment that a coherent national style would develop gradually. Even with the dynamic form of the modern skyscraper becoming the accepted focus of architectural development, most architects agreed, at this point, with Henry Van Brunt:

> The opportunity of the architects of America to develop a characteristic modern style lies in the application of these principles [of precedent] to the expression of modern structure of appropriate forms of art, not, on the one hand, by devising new words and phrases, nor, on the other hand, by forcing historical formulas to perform this difficult service
>
> It is also self-evident that . . . the directing of these great forces of civilization toward an appropriate and adequate expression in architecture, can only be secured by high convictions on the part of the architects; and that these high convictions are only possible to a learned profession — a profession thoroughly versed in the history of art, familiar with precedent.101

American architects looked forward to the gradual "aestheticizing" of the steel-framed tall building by the most appropriate lessons from the past and through this process to an eventual American style. They anticipated reform, or an evolutionary change within the framework of the existing order. They did not conceive of revolution.

4

A New Eclecticism

All good architecture has been eclectic in the forming.
C. Howard Walker, 1905

Between 1900 and 1921, style, or the most appropriate appearance of a building, continued to be the concern uppermost in the minds of Americans who wrote about their architecture. Although many had expressed high hopes that the World's Columbian Exposition would resolve questions of style once and for all, it soon became more and more apparent that the Renaissance forms inspired by the Chicago Fair were not appropriate for all building types and uses. They were considered especially unsuitable for the tall building.

Contemporaries responding to the growing complexities of architectural requirements and the greater demands of modern society, embodied to a large extent in the tall commercial building, reasoned that these could be met most effectively with the broadest and most flexible repertory of styles possible. Furthermore, because they thought design was meant to be appropriate to the building's purpose, many, like Professor A.D.F. Hamlin of the School of Architecture at Columbia University, judged that the greater the choice of style, the better would be the ultimate architectural integrity of such a building. "Eclecticism," he declared in 1905," . . . a wise, reasonable, broad and artistic eclecticism—will mark the progress of artistic design in the twentieth century."[1] Like most of his generation Hamlin understood that the eclecticism he endorsed was historically based. He elaborated on its particular characteristics:

> Personally, I hail the revived use of forms borrowed from Gothic architecture because we have so many kinds of buildings to which they are artistically applicable, and thus they enlarge the resources of modern design So also do I hail the classical revival which, since 1893, has done so much to give dignity, breadth and nobility to public buildings.[2]

Indeed, Gothic and classic style variants dominated the choices made during this period.

Approbation for renewing an eclectic spirit came also from those who

rationalized that it would play a major role in the development of a national style. The desire for such a cohesive style had not diminished since the period before the Chicago Fair. The persistent elusiveness of an "American style" still bewildered many architects and architectural writers. Implicitly, most of them still considered it the ultimate and inevitable goal of our architectural development no matter what character the development took. Ernest Flagg, who lamented the lack of an American style was essentially hopeful of the eventual appearance of such a style based on "the particular process of development which works everywhere else," and which he defined as "a slow system of evolution from what has gone before."[3] In fact, the notion of a gradual evolution of style initiated by precedent perfectly suited the rationale behind eclecticism. Even many proponents of one particular style, such as the supreme Gothicist, Ralph Adams Cram, found in eclecticism "no architectural retrogression," but rather a "steady and startling advance."[4] It is also important to realize that in the judgment of Cram and others, like Hamlin, this was a different sort of eclecticism from the "promiscuous commingling of styles" of the post Civil War era. Whereas most had judged the earlier forms to have been vulgar and undisciplined, this new eclecticism was seen as manifesting a proficient and sophisticated grasp of the essentials of style.[5]

In the final analysis, Cram considered the choice of styles worthwhile because he believed "each is contributing something to the mysterious alembic we are brewing."[6] It was almost as if Cram considered eclecticism in architecture something akin to the contemporary "melting pot" of American society, so that architecture, in its unresolved state, did in fact reflect the American character. Cram even said, "in that fact lies the honor of our art, for neither is society one, or even at one with itself."[7] However, for Cram this situation was the process of development and not the end:

> I believe all the wonderful new forces now working hiddenly, or revealing themselves sporadically, will assemble to a new synthesis that will have issue in a great epoch of civilization as unified as ours is disunited, as centripetal as ours is centrifugal, as spiritually efficient as ours is materially efficient; and that then will come, and come naturally and insensibly, the inevitable art that will be glorious and great, because it shows forth a national character, a national life that also is great and glorious.[8]

Cram, like most of his contemporaries, equated progress with evolution. In other words, he believed that the final resolution of the process inevitably would be superior to what one began with. It is ironic that the rousing forecast for the future of architecture, and civilization through architecture, given by the arch-conservative Cram sounds similar to the goals promulgated by the proponents of modern architecture. Progress, however, was an ideal almost universally aspired to at the beginning of the twentieth century. A more glorious future for architecture was desired by

both the traditionalists and the "radicals"; only the degree, kind and process were open to question and debate. During this period nearly every American architectural writer looked forward to some kind of new style. European radicals or modernists did not hold exclusive possession of the concept of a new, a modern architecture; in fact, that the concept of the new existed this early in America helped encourage the eventual ascendance of modernism. On the other hand, the essential difference between the European and American approaches to such a change remained. American architects conceived of the means toward that end as evolution; the Europeans as revolution.

Although the renewed eclecticism of this period was initially characterized by a return to choices of historical styles, its subsequent development actually undermined the preeminence of precedent. Because flexibility and choice are inherent in the nature of eclecticism, in time it allowed for the acceptance of unexampled architectural treatments, particularly when they were deemed more suitable than historical styles. The increasing complexity of architectural technology and functional requirements demanded greater flexibility in design. The most consistent way a profession grounded in a reverence for precedent and a concern for appearance could respond was by expanding the choice of styles. Once the eclectic spirit was reaffirmed, it opened the door to a toleration of unprecedented styles, which were used when historical styles were deemed inappropriate to a function or incompatible with construction. Yet, generally the ideal remained a gradual evolution toward the future national architecture: a natural outgrowth from the example of appropriate historical styles, but with careful integration of contemporary innovations.

The primary catalyst for the new eclecticism was the tall building. Hamlin wrote in 1916, "Our skyscraper architecture is omnipresent, the most conspicuous, revolutionary and American architectural product of the last twenty-five years It has been more cussed and discussed' than any other modern type."[9]

In fact, the attempt to reconcile historically based styles with the unprecedented height and metal construction of the tall building began almost immediately after its introduction, in spite of the reservations of writers such as Schuyler and Ferrée.[10] The majority of the tall building commissions before 1910 displayed external details and massing derived either from the "Richardsonian Romanesque"[11] or from Renaissance styles.[12]

Very early in the new century, however, and certainly by 1905, several voices were raised complaining that a style, basically derived from post and lintel or arch and vault structural systems and most appropriate for low buildings, was not well suited to soaring towers (figs. 9–11). The Gothic style was proposed, by those who objected, as the appropriate alternative.

Frederick Lamb's proposal for the modern use of the Gothic, which can serve as a model for this position, argued: "The classic, with its column and lintel does not solve the problem. The modern office building with columns at the bottom or at the top, as seemingly dictated by accident [as opposed to necessity, one supposes] is not a thing of beauty."[13] He rebuked the classically oriented architects for "the uncertain and wandering efforts of the designer when some problem is given for which there is no precedent, as, for example, a modern office building."[14]

Skepticism about the appropriateness of classical forms for tall buildings was quite widespread. Two contemporary reviewers of the architecture of McKim, Mead and White wrote that the "good sense" of the firm caused them "to avoid [rather] than to seek opportunities to plan skyscrapers," because, "the ideas and the theory of design for which they [McKim, Mead and White] have stood would appear at its worst in relation to the architecture of very tall buildings."[15]

Lamb's argument for the Gothic is worth examining in some detail because it provides an example of the contradictions between the serious concern that contemporaries persuaded themselves that they were giving to the integrity of skyscraper structure and their predilection for external articulation. Not surprisingly, Lamb began by recognizing and elaborating upon two particular similarities between the skyscraper and the Gothic cathedral. The first was the extreme height they shared. As Lamb said:

> In Gothic architecture alone, we find examples which will bear comparison with modern buildings. In Gothic architecture alone are those possibilities of height sufficient to meet modern requirements
>
> It is for that reason that Gothic remains as the style from which a possible inspiration may be received for the tall building of modern times. The height of the Gothic building was only gauged by constructional limitations, not by design. We can imagine these buildings as reaching the sky, if such a thing were possible, without shock to the aesthetic sense. Can the same be said of any other style?[16]

Lamb was also struck by the analogous structural systems. He described the coincidence:

> It [Gothic architecture] foreshadowed the modern development of construction. The buildings are supported upon piers, and in buildings, the walls become mere filling in, just as our wall spaces are but the connecting links between the main lines of support
>
> While modern steel construction has eliminated the necessity for many of the delicate constructive expedients of the old style, it still so closely duplicates its main lines as to suggest the possibility of similar treatment in the future of detail and ornament.
>
> There is a marked similarity in the upward growth of the Gothic building and in the modern office building[17]

On the other hand, Lamb could only conclude from this that "undoubtedly, [it] foreshadows a similar development in detail."[18] Essen-

tially, in other words, his argument breaks down to a rationale for using Gothic details to enhance the exteriors of tall buildings. Nevertheless, the fact that such an argument was presented and based, albeit superficially, upon notions of structural integrity, could only increase the general awareness of the steel frame, not to mention that it gave such structures more positive assessments.

It was not uncommon for most American architects at the turn of the century to appeal to a kind of organic and functional kinship between Gothic structure and the newly developed steel frame. Although we correctly associate the greatest influence of an organic tradition with the young Western architects such as Sullivan, Root and Wright, most of their contemporaries were aware of, and not unaffected by, the arguments of structural rationalists such as Viollet-le-duc and Gottfried Semper. For example, Bertran Goodhue, of the firm of Cram, Goodhue and Ferguson, the architects of the new Gothic buildings at West Point and a group much admired by Lamb, at least paid lip service to these notions, professing: "The true Romanticist welcomes steel or concrete construction as his brother of the twelfth century must have welcomed the counterthrusting arch and flying buttress."[19]

On the other hand, A.D.F. Hamlin was concerned with whether contemporaries were liable to misconstrue the relationship between style and structure, especially when adapting the Gothic to modern construction. As he warned, "in much of the current discussion and criticism it is the forms of Gothic architecture that are in mind and not its principles."[20] He went on to explain that, in his view, the principles of Gothic architecture were based on practical and structural logic, and were clearly distinguished from the principle of the ideal at the root of classical styles of architecture.[21] Hamlin exposed the nineteenth-century tendency to confuse style and principle of design and, at the same time, the major difficulty in Lamb's logic by pointing out:

> If . . . it is a question merely of using Gothic forms, fitting them as best we may to modern buildings . . . it is clear that we are, after all, proceeding not upon the Gothic but upon the classic principle. We are doing precisely what the Romans did when they adapted Greek forms to arched and vaulted structures.[22]

However, Hamlin was not critical of the "Roman" methods or of the application of one structural form to the surface of a new one, as we might have expected him to be from the tenor of his statement, or as we might expect the modern architect to be. On the contrary, he thought it a "perfectly reasonable procedure" and particularly applicable to modern architecture, in which "the prevalent framework or core of durable but unsightly materials—concrete, rubble, or brick— . . . requires to be dressed in a more presentable outer vesture.[23] It is, of course, significant to note that Hamlin upheld the prevalent opinion that modern materials were inherently unaes-

thetic and advised covering them with some sort of embellishment. What is more, he invoked the authority of a divine analogy for support: "This is what the Creator has done in the design of the human body, concealing its unsightly interior mechanism and framework within the exquisitely beautiful outer covering of skin."[24] Hamlin's discussion should make it more plausible that one who was sensitive and insightful about the essential architectonic and theoretical differences between the classical and the Gothic design methods could still hold, without self-conscious contradiction, the attitude that skyscraper metal construction was unaesthetic and better covered up, even if Gothic vaults were not.

However, the very acknowledgment of a notion such as structural integrity would in the long run permit discussion of it and encourage its acceptance if other factors existed to encourage it. Hamlin advised that if the Roman method was to be followed, we should not imagine that we were also reproducing Gothic principles. The "real question," as he defined it then, "between our use of Roman and Gothic forms, is a question of appropriateness, fitness, adaptability and final artistic effect":[25] the principle of an external ideal rather than an inherent structural logic. In fact, Hamlin did not see the need to restrict the "ideal" treatment of the metal frame building to the Gothic alone. His reasoning, conditioned by eclecticism, led him to conclude:

> There seems to be no good reason for excluding from buildings designed upon this [Gothic] principle such traditional forms and details as are applicable . . . and whatever will make a structural design more beautiful may legitimately be employed.[26]

With final, irrefutable, historicist-based logic, he contended, "We cannot ignore tradition. No age has ever done so. Traditions affected even Gothic architecture Our age is the heir of all that have gone before."[27] Thus, Hamlin made eclecticism the logical link between the past and the future. Most contemporaries agreed with him and the Gothic became the favorite style for American skyscrapers during the second decade of the twentieth century.

The Woolworth Building in New York City (figs. 12 and 13) was the most prestigious and effective of the Gothic skyscrapers. Designed by Cass Gilbert between 1909 and 1913, with terra-cotta Gothic ornament cladding the steel frame, it was the culmination of this type and the tallest building in the world until the Chrysler Building surpassed it in 1930. Gilbert's own thoughts on the design indicate that he associated the soaring height of the structure with the choice of the Gothic mode: "To me a skyscraper, by its height which makes the upper parts appear lost in the clouds, is a monument whose masses must become more and more inspired the higher it rises."[28]

Montgomery Schuyler had a slightly different reaction and in his

review of the building raised several points regarding the most appropriate treatment of skeletal construction which indicate that, already, some traditional attitudes were being changed. Schuyler was emphatic: "The Woolworth most unmistakably denotes it is a skeleton."[29] "Nobody," he maintained, "could possibly take it for a masonic structure. The uprights of the steel frame are felt throughout and everywhere."[30] Schuyler approved this effect but he did not, as a consequence, disparage the use of historic styles. In fact, he attributed the unmistakable expression of structure to the particular material and handling of the Gothic sheathing. In other words, this perceptive critic sanctioned the expression of integral skeleton construction by means of an appropriate "stylistic" covering.

In discussing the most appropriate expression of the tall building Schuyler revealed that in current practice, "Some architects endeavor to express that primary fact, [our tall buiilding is . . . a frame building] and some find it more convenient to ignore it."[31] As Schuyler reported, it was now being argued that, "the actual structure, the steel skeleton, *must* be overlaid, and in part concealed."[32] Interestingly, the argument for a covering he reported was now based on function and not on the need to embellish an unaesthetic form. Now the steel frame had to be fireproofed. Schuyler reported that "the consensus of architects is that the frame must be enveloped or wrapped, with incombustible material for security against fire."[33] Whereas it had long been realized that a metal frame was susceptible to buckling at extremely high temperatures, more conservative architects and critics began to make much of this "rationalist" argument in favor of sheathing or covering skeleton construction.[34] It helped to mask their inability to see the exposed frame as an aesthetic object and to justify their use of historic forms to envelop the frame and dignify their designs. However, the question of whether or not to express the skeleton remained open, but with more traditionally oriented designers refuting those who advocated an organic expression with an argument based on necessity.

The majority of the profession "fire-proofed" their structures or gave them an overlay,[35] but Schuyler noted that a fundamental difference in attitude still divided them, a difference based on conventions of beauty and stylistic preferences. On the one hand were those who assumed that the envelope was superficial and endeavored "to express the actual structure behind it,"[36] such as in the Woolworth Building. On the other hand were those who treated the envelope like a wall which carried itself.[37] One architect who proceeded according to the latter assumption argued that it was "by no means necessary to announce the factors of structure behind the shell, as if the building were a radiograph . . . provided the whole effect is consistent with the type of construction and does not deny or oppose it."[38]

Schuyler, who seemed to have reconciled himself to the elimination of the wall, now criticized those who, as he described them, showed little

interest "in attaining a characteristic and expressive treatment,"[39] and continued to face their skyscrapers with masonry, "wastefully cut . . . only adjusted to it mechanically, purporting to be an actual and self-carrying wall of masonry."[40] On the other hand, he applauded those who desired "the expression of a frame which must be wrapped to protect it from the elements," and who used terra-cotta sheathing "which can be moulded so as to conform to the structure which it at once conceals and reveals."[41] Terra-cotta, albeit molded into Gothic forms, was, according to Schuyler, what allowed for the "great architectural success . . . of an expressive treatment" in the Woolworth Building.[42] In 1913, Schuyler argued against the false impression or structural dishonesty of a load-bearing wall, but significantly *not* against the adaptation of historic styles to the expression of the new structural system, and through his discussion indicated the ongoing desire to reconcile traditional style to the technological necessity of structure.

If the Woolworth Building was the most impressive of the Gothic skyscrapers, even in the opinion of contemporaries, the design for the Chicago Tribune Tower of 1922 was the one for which there were the greatest expectations. The international competition for a headquarters building, which was announced by the Chicago Tribune on June 10, 1922, stated as its primary objective: "To erect the most beautiful and distinctive office building in the world."[43] The first-prize winner was a design for a Gothic-styled tower, submitted by John Mead Howells and Raymond Hood (fig. 14). Indeed, 1922 could be considered the peak year for Gothic skyscrapers. Not only first prize, but also third prize went to a Gothic design.[44] Of the approximately 260 designs entered in the competition, forty-two were Gothic-based or some variant thereof.[45] Fourteen of the fifty honorable mentions were awarded to Gothic designs. In other words, the Gothic was distinctly preferred among entrants as the style which would most likely result in the most beautiful office building in the world.

It is telling, however, that the winning architects, Howells and Hood, felt compelled at this point to justify their choice of style more specifically in terms of the expression of structure and function than in terms of beauty, the same attitude Schuyler had applauded in the Woolworth Building:

> It climbs into the air naturally, carrying up its main structural lines, and binding them together with a high open parapet. Our dispositon of the main structural piers on the exterior has been adopted to give the full utilization of the corner light in the offices, and the view up and down the Avenue.
>
> Our desire has been not so much an archaeological expression of any particular style as to express in the exterior the essentially American problem of skyscraper construction, with its continued vertical lines and its inserted horizontals. It is only carrying forward to a final expression what many of us architects have tried already under more or less hampering conditions in various cities. We have wished to make this landmark the study of a beautiful and vigorous form, not of an extraordinary form.[46]

Moreover, they felt it necessary to mitigate the purely decorative extravagance of their crowning buttresses by explaining them as also functional:

> It is perhaps not necessary to call attention to the fact that the upper part of the building has been designed not only for its own outline and composition, but for the possibilities of illumination and reflected lighting at night.[47]

On the other hand, there is no reason to assume that the choice of the Gothic style by Howells and Hood did not reflect their own aesthetic preference at this time. The client had indicated no stylistic preference.

The matter of aesthetics, however, figures prominently in the architectural program for the competition and in the deliberations of the jury. The basically traditional aesthetic criteria which determined the winner, while reflecting the preference of the majority of American entrants, were also related to the fact that the five-man jury consisted of one architect and four businessmen.[48] Art had achieved a worthwhile commercial value, as the jury made clear in its report:

> It is the first time that a corporation, civic, commercial or political (and the Tribune as a great newspaper represents all three types) has recognized the importance of a commercial building as a force for beauty and inspiration in the daily life of the average American citizen.[49]

Together, through the Tribune competition, American architects and American businessmen confirmed, on an international scale, that the commercial skyscraper symbolized American architecture and that it could be expressed through traditional aesthetic forms. Yet it is interesting that the jury also felt that it was important to announce the competition as another indication of American creative parity, even superiority: "One gratifying result of this world competition has been to establish the superiority of American design. Only one foreign design stands out as possessing surpassing merit."[50]

Ironically, the design which the Jury considered the only worthy foreign entry[51] marked the end of the Gothic and the beginning of original or nonhistorical styles as the most appropriate for the expression of the American skyscraper. This design, received at almost the last moment, was created by Eliel Saarinen of Finland, and was awarded the second prize in the competition (fig. 15). Noted the awed jury, the Saarinen design was "of such unusual beauty," and displayed "such a remarkable understanding of the requirements of an American office building as to *compel* its being awarded second place."[52]

Critics were even more certain of its merit; many complained that it had not been awarded the first prize. A critic for the *Architectural Record*, for one, judged it superior to the Howells and Hood first-place design,

because he considered it, significantly, an *original non-historical design*. As he explained:

> We are confident that the second prize design will have such an effect upon our designers, coming at a critical time as it does, when we are thoroughly "fed up" with the old method of "dressing" our steel buildings, that through its influence will be born a really distinctive, a truly American Architecture.[53]

Writing in 1928, Harvard architectural historian George Edgell reviewed the exceptional features of Saarinen's design:

> The vertical lines were further emphasized and the main verticals of the great structural piers were indicated on the exterior of the building. Great vertical slits were opened from base to top . . . which indicated the structure, showed the steel lines, and revealed the cage-like frame-work of the whole. At the same time an attempt was made, concurrent with the expression of structure but independent from it, to shake off all classic and even historic reminiscence and design an ornament as original as the structure.[54]

As Edgell's assessment indicates, the Saarinen design represented a confirmation of the expression of the structure and a move away from the predominance of historical styles for the exterior. On the other hand, the reader will appreciate that, while Saarinen's design was free of overt Gothic details, the extreme verticality of the silhouette, the effect of clustered, attenuated piers rising to delicately embellished finials which in turn articulated a receding tower effect at the crown, were all closely related to Gothic prototypes.

Interestingly, the quality of the Saarinen design prompted a timely and positive critical evaluation from the old master of original skyscraper design, Louis Sullivan himself. Inspired by its originality, Sullivan envisioned Saarinen's design as the promise of a new age, one which could not be held back any longer. Furthermore, Sullivan saw a clear confrontation inherent in the distinction between first and second prize in the competition, between precedent and progress:

> The first prize is demoted to the level of those works evolved of dying ideas The apposition is intensely dramatic to the sensitive mind The Finnish master-edifice is not a lonely cry in the wilderness, it is a voice resonant and rich, ringing amidst the wealth and joy of life
>
> Qualifying as it does in every technical regard, and conforming to the mandatory items of the official program of instructions, it goes freely in advance, and, with the steel frame as a thesis, displays a high science of design such as the world up to this day had neither known or surmised. In its single solidarity of concentrated intention, there is revealed a logic of a new order . . . most graciously accepted and set forth in fluency of form.[55]

Moreover, Sullivan criticized the Gothic design as "scene painting" rather than architecture, an illusion based on a "false premise,"[56] that is, the prem-

ise that architectonic beauty is achieved through an appliqué of carefully wrought details borrowed from the past.[57]

The demise of the Gothic-style skyscraper and the influence of Saarinen's design is clear from the appearance of subsequent skyscrapers and in the writing about them. For example, the clearest visual adaptation of the Saarinen style was conceived by Raymond Hood, who quickly abandoned the Gothic of his first-prize winner in favor of the second-place type. Hood's Radiator Building in New York City was completed in 1924, indicating the immediacy of Saarinen's influence (fig. 16). The conspicuous black vertical piers, the Saarinenesque finials of which were picked out in gold, made the building a landmark from the start,[58] and it was cautiously and tentatively approved by Harvey Corbett in his review of the *Architectural Record*.[59] The New York Telephone (Barclay-Vasey) Building, (fig. 18) completed in 1926 by Voorhees, Gmelin and Walker, although more massive and less towerlike,[60] still owed its emphasis to the vertical piers, and its use of original ornament—here Art Deco—on the tapered ends of those piers, to the influence of the Saarinen design. The appearance and overwhelming approval of the "original" Saarinen design marked the beginning of the ascendancy of unprecedented, even modernistic, skyscraper design. Originality was no longer eschewed. As Corbett, viewing the Radiator Building, warned, "One should be slow to criticize the exercise of free imagination which soars without restraint of the conventions of the past."[61]

However, the Saarinen design did not create the tolerance for and acceptance of original, unprecedented design. It catalyzed an attitude which had been slowly developing for several decades. During the years between 1900 and 1922, the search for the most appropriate style for the skyscraper had become almost synonymous with the search for a national style. At the same time, architects and critics grew more intent on expressing the skeleton, but less sure of any one solution. Writing in 1916, A.D.F. Hamlin asserted that one of "the two most potent forces . . . that have transformed modern American architecture" was "the development of steel skeleton construction,"[62] but "we have not yet solved the problem of the ideal artistic treatment of the skyscraper."[63] The renewal of eclecticism during this period provided greater design flexibility, but not only in the choice of historic styles. It also tolerated the use, when appropriate, of unprecedented styles, including rational and original treatments and eventually, "modernist" treatments.

For strictly commercial commissions, "economical" and "practical" or barely decorated designs continued to be preferred.[64] Although these were not considered "beautiful and exhilarating pieces of architecture" or "a satisfactory solution of the problem of the design of skyscrapers,"[65] they nonetheless extended the example and opportunity for more "utilitarian" or less decorated design.

Among the supporters of precedent, on the other hand, were those like

Schuyler and Gilbert, who believed in the expression of structure. There were also those, like stylistic and structural purist Russell Sturgis, who were amazed that any architect could "conceive of a Gothic style based upon many-storied buildings divided into small rooms,"[66] since this was so completely the antithesis of the single and soaring open space of a Gothic cathedral. As early as 1900, Sturgis recommended, even in regard to the historical styles, a moratorium on decoration and a concentration on structural and formal integrity:

> Things might be better if architects were allowed to build very plainly for awhile. If no one was held bound and committed to perpetuate the usual amount of architectural detail the designer might get on better with his masses If the architects were compelled to fall back upon their buildings, their construction, their handling of materials as their sole source of architectural effect, a new and valuable style might take form, unpleasing as some of its earlier examples might be.[67]

The fact that practitioners and commentators other than those directly associated with an original treatment of skeleton construction argued the merits of a rational or logical expression of structure, is significant in how modernism developed in this country. Certainly the greater the number of voices calling for this approach, the more acceptable it became, and the sooner so.

Among the "radical" styles increasingly tolerated in the new eclecticism inspired by the design challenge of the tall building were ones variously labelled in the literature between 1900 and 1922 as commercial, logical, Secessionist and, ultimately, modernist. Notably, in 1913, Ralph Adams Cram identified and implicitly accepted as significant among all the styles he saw operative at the time, two new ones: what he called "steel frame construction and the Secessionist element."[68] Exposing his conservative caution Cram described the steel-frame as "the *enfant terrible* of architecture" which "may grow up to be . . . serious-minded."[69] What he associated with the Secessionists is less clear to the modern reader and his own definition remains provocatively vague. But his allusion to Post-Impressionism and Cubism in describing Secessionism certainly elicits the notion that he considered it radical in the extreme.[70] Somewhat more explicitly, he said this element "is the latest . . . to be introduced, and in some ways . . . is the most interesting," but shows itself "little except in minor domestic work . . . but there . . . is stimulating."[71] Yet, however hesitant and superficial was his analysis of these styles, the fact that Cram discussed them in his catalogue of "Style in American Architecture" is both striking and consequential. Cram was a conservative, the greatest American proponent of not only the Gothic style, but also of a renewal of the medieval spirit, and his stature in the profession was considerable. If not approbation, Cram's discussion of these radical elements at least granted them recognition and credibility and at an early date. He even hinted at their future significance.

In 1921, another conservative critic, C. Matlack Price, discussed "The Trend of Architectural Thought in America" and referred specifically to the "modernists."[72] As a group he identified them as devoting themselves "diligently to discovering some form or forms of architectural expression which would owe nothing to precedent."[73] He named Louis Sullivan as "the pioneer of the new school . . . who made such brilliamt departures from all known architectural precedent."[74] On the other hand, he also called Sullivan and his followers "'The American Secessionists,' after the Viennese Secessionists,"[75] establishing an early association between a group of American nontraditionalists and the European modernists in terms of "radical . . . artistic and architectural convictions,"[76] if not in more substantial terms of architectonic form and theory. However, not surprisingly, Price concluded that, "I should still feel inclined to doubt even the ultimate authoritativeness of the 'Secessionists' kind of design."[77]

Sullivan had himself on numerous occasions[78] articulated his rejection of the historical styles which he considered "ever-futile attempt[s] to detach an art from the civilization which gave it birth," and which resulted in "completely ignoring the possible suitability of twentieth century thought for our twentieth century conditions and demands."[79] In fact, Sullivan was one of the most ardent believers in an indigenous style:

> Our real, live, American problems concern us here and now
>
> All this talk about Classic, Gothic, Renaissance, etc., merely indicates inverted thinking, and has nothing to do with our case. Our case is the big urge of American life as well as its many lesser urges.[80]

When Sullivan wrote this in 1905, he was in effect a single voice[81] calling for a complete disavowal of historic styles. But by 1922 a new generation had matured with their commitment to precedent loosened by the intervening discussions and debates over the appropriate expression of the skyscraper and by an increasing awareness of European avant-gardism. By 1922, Sullivan's arguments and originality began to appear less disruptive and arbitrary.

Within the gradual accession of original and unprecedented styles into what Cram had called the "mysterious alembic" lies the major significance of the eclectic spirit of the first quarter of the twentieth century for the future development of modern American architecture. Indeed, this realization makes it difficult not to agree with the contemporary American assessment of the period that "all good architecture has been eclectic in the forming."[82] Because the tall building emerged more and more securely during these years as the main measure of achievement in American architecture, the design challenges posed by its structure and the several solutions posited, no matter how unprecedented, gained greater attention and credibility. Once such alternatives to the predominant historical styles were acknowledged and accepted, even to a limited degree, they were not denied

continuing development. By 1922, the evolutionary process that character-
ized the development of modernism in American architecture had reached
the crucial point where original and nonhistorical styles were preferred to
styles based on historical precedent in the minds and on the buildings of
American architects. They no longer considered traditional forms to be the
most appropriate.

5

The Ascendance of Modernism

> The common conception is that it means a radical change in the looks of things.
>
> Raymond Hood, 1929

What is modernism? This was the question being asked over and over again in American architectural literature following the Chicago Tribune Competition of 1922. The discussion that ensued, however, provided little in the way of a consistent or unequivocal answer.

Between 1922 and 1929, awakened by the unprecedented stylistic quality of Saarinen's Tribune Competition design, American architects became more attuned to the demands of modernity and increasingly conscious of the urgent need to have their architecture appear up-to-date; they became preoccupied with the question of how their newest architecture should look. The discussion of modernism in American architecture was, therefore, initially and primarily a discussion of stylistic designation.

The quandary over modern style was as great, if not greater, than the stylistic confusion of the preceding decades. The core of the dilemma, once again, was the predilection of Americans to view architecture as a matter of stylistic choice; during these years, Americans considered a variety of styles to be modern. Confusing the issue further, however, was the inconsistency with which terms like modern and modernism were used by American architects and architectural writers. A discussion of the evolution of these terms is, therefore, necessary to more fully understand the context in America within which the debate over modern styles took place.

Today, the term *modern*, as it applies to most of the arts, cannot be considered a neutral word. It is fully charged with references to a very particular period, attitude and formal manifestation. Referring to modern literature, critic Irving Howe defined the term modern as distinct from "the merely contemporary." As he explained, "where the contemporary refers to time, the modern refers to sensibility and style, and where the contemporary is a term of neutral reference, the modern is a term of critical placement and judgment." More specifically, Howe noted that "modernity consists in a

revolt against [the] prevalent style [of the culture]."[1] The same connotations that Howe describes may be assumed for *modern* as it applies to architecture, especially in the sense that it was used by the European avant-garde architects in the 1920s and thereafter.

In the context of avant-garde European architecture the word modern already had the fully charged meaning that Howe describes. For the European avant-garde, modern meant a specific sense of the new age, a rejection of tradition and precedent, which were to be replaced by a revolutionary theory and form.

In the United States between 1924 and 1929, however, the word modern had not yet fully acquired the connotations Howe describes, particularly the notion of a revolt against the prevalent style of the culture. During these years, the meanings of the words *modern, modernism, modernistic*, were in a state of transition and were not always clearly distinguished in American architectural literature. In the American context, *modern* initially remained a more neutral term, while its derivatives, such as *modernism* or *modernistic*, were adopted to describe new architectural forms which at first appeared to be radically different, even bizarre, to many Americans. For example, George Edgell, writing in 1928, used "modern" as an all-inclusive term, but selected "modernism" and "the modernistic movement" to denote architecture which had "affinities with those abroad which are producing such interesting — and oftentimes . . . such bizarre — buildings in Germany and the Netherlands." Not surprisingly, Edgell also included among the "modernistic" such other nontraditional European developments as "the modernism of Scandanavia and the movement which produced the Paris Exposition of 1925."[2] Because in the American architectural mind style was usually associated with the look of a building, the radically changed and aggressively nonhistorical forms that Americans saw developing in Europe were usually described by means of a more exaggerated term like *modernistic* to distinguish them from contemporary American developments.

The basic distinction between the American and the European conception of modern architecture is made clear by the different use of terms. The Europeans conceived of a radical transformation in the whole nature of architecture, including structure, materials, theory and design, which they called modern architecture after the new age it was seen to reflect. The Americans, on the other hand, first recognized and then began to cultivate a novel *appearance* in architecture which they called modernism or the modernistic style. The Europeans never called modern architecture a style; but, the Americans always considered the radically changed look of architecture as a new style or styles.

In general, modern remained the more neutral and modernism the more fully charged term in America during the 1920s. By 1929, this had changed. Through 1928, for example, "modern" could still be used to

describe all contemporary or recent architecture including restrained classicism or original eclecticism, as Edgell suggested. By 1929, however, the meaning of "modern" in American usage was nearly synonymous with "modernism"; by this time it was difficult to use the word modern in any of its forms and not connote an advanced or radical design. The connotations of the terms had become more consistent because, by 1929, Americans had made substantial changes in the forms they were willing to accept as appropriate. Thus, in 1929, architect Raymond Hood was able to state, "There is no need to tell anyone that art has 'gone modern'," and clearly mean that it had gone for a "radical change in the looks of things."[3] In fact, by this time, those architects who did not want to be considered extreme rejected any form of the designation "modern," preferring to be called "progressives."[4] Once the confusing situation over terminology during this period has been addressed, it is easier to understand the debate which was taking place at the same time over the most appropriate forms for the newest American architecture, because the often inconsistent terminology reflected the process of transition.

Following the Tribune Competition in 1922, American architects began to take a greater interest in nonhistorical or original styles because these appeared to be more up-to-date when compared to Ionic columns or ribbed vaults. For the same reason, Americans began to give more attention to the unprecedented forms developing in Europe, although many of these appeared to have no decorative characteistics whatsoever. For the most part, the Americans initially identified the European developments as several distinct new national styles, all of which, because of their exaggeratedly new forms, they labelled "modernistic," meaning extremely modern. Among the modernistic styles, Americans usually included German and Dutch avant-garde architecture, the designs presented at the 1925 Paris Exposition, the work of the Viennese Secession, and the designs of Le Corbusier, who was particularly known through his architectural treatise, *Vers Une Architecture*.[5] Added to this ferment of European stylistic influences were the most recent American developments, specifically a "contemporary" or streamlined version of classicism, and the massive set-back form for skyscrapers, both of which were also originally believed to fulfill Americans' desire to gradually update the look of their architecture. It is apparent that in addressing the problems of modernism and the most appropriate expression for advanced American architecture, a variety of choices and opinions, often apparently contradictory, were offered. Not the least of these suggestions was modern classicism, which, by today's standards, is certainly the most contradictory.

Although the general tendency in design following the Tribune Competition can now be seen to have been moving toward modernism, the conservative viewpoint, before 1928, still commanded serious attention among

American architects. What turned out to be the final and among the most cogent arguments of the conservative position were made, in fact, in two studies of American architecture published in 1928: *The American Architecture of To-day* by George Edgell of Harvard University and *American Architecture* by Fiske Kimball of New York University.[6] Both books were written by respected professional art historians and were among the first book-length studies to attempt a comprehensive treatment of American architecture. Both Edgell and Kimball provide a valuable insight into what is today considered a reactionary view. They spoke for an attitude that was later condemned, not because it was inherently wrong or unreasonable, although some professed to believe that. Indeed, a retrospective reading of their views reveals much that is judicious. Their attitude was overruled because it lost in popularity amid a general tendency, even in this country, to idealize and polarize the modern. Americans were eventually unconvinced that traditional forms could appropriately express the fervent newness of the modern age.

Confirming his skepticism concerning modernism, George Edgell, in the introduction to his study, elaborated on why he considered the all-inclusive definition of modern to be the most meaningful one:

> Modern American architecture includes all the architecture of America which has recently been built, or is being built to-day. It includes the conservative and the radical, the archaeological and the original. To limit modern architecture to that which seems to embody what are called modernistic tendencies would be not only foolish, but arrogant. The architecture which to-day is regarded as unprogressive, a generation from now may be in the van.[7]

Kimball shared his attitude. "'Modern'," he wrote, "is a relative term: its meaning changes from generation to generation."[8]

In fact, in 1928, Edgell could still believe that "the whole question of modernism in American Architecture is under dispute."[9] In order to justify this he explained his distrust of originality, which in his assessment included modernism:

> Practitioners of all the arts to-day have made a fetish of originality. Straining every nerve to be new, they often lose sight completely of what should be their steadfast aim: *the expression of the beautiful*. Striving merely to be different is as stupid as making direct copies of an ancient masterpiece The danger which the modernist runs is an excessive fear of the past and its precedent.[10]

Edgell's distrust is based on an important aspect of the conservative view, the belief that the ultimate end of architecture is the expression of beauty. It is clear that he felt that originality and modernism undermined the beautiful, which he believed was grounded in precedent, rather than self-conscious novelty.

Both Edgell and Kimball concluded, therefore, that the leading positive influence on the future of American architecture was the "contemporary classic school."[11] Both held up the work of the firm of McKim, Mead and White as the paradigmatic example of the style's "elementary uniformity and harmony."[12] Edgell, for instance, praised one of the firm's last tall building designs,[13] acknowledging that it followed what Schuyler had earlier observed was the less truthful, less expressive approach to skyscraper design, that is, the sheathing of the steel skeleton with masonry which concealed the structure and purported to be a wall. Commented Edgell, "It will thus be condemned by many critics; as deception if they be moral ones, as old-fashioned and unprogressive if they be modernists."[14] But, in defense of this conservative preference, Edgell offered:

> Greater familiarity with steel construction means less necessity for expressing it in design. At first, when the system was new, men clamoured for honesty of expression in design. If a wall were only an envelope, incapable even of supporting its weight, such a fact should be advertised on the exterior of the building. As we become more accustomed to the construction, however, we realize that the very mass and height of the building proclaims its construction. Little thought is required to convince us that a masonry wall thirty-five to fifty stories high is not self-supporting. Familiar with the fact, we become less insistent in design upon the proclamation of the obvious.
>
> The problem is much broader than that of a mere expression of structure.[15]

And, in 1925, Kimball had agreed, "For better or worse, the struggle to express the steel frame, so burning in the nineties, has become a dead issue."[16]

Kimball's argument in support of the contemporary classic was more elaborate and interesting than was Edgell's; indeed, it was a sophisticated equation between an emphasis on form in architecture and the return to formal concerns in avant-garde European painting. In 1924 Kimball first objected to "the current view that American architecture . . . has turned its back on modernity and reconciled itself to a barren reproduction of the classic." Such was "not the true or vital view," he insisted.[17] Kimball believed that classical ideals of harmony, clarity, and balance were essential to any perception of beauty or design and he believed that these ideas were flexible and adaptable to new conditions. Kimball was not advocating the exclusive use of "archaeological" classicism or the decorative vocabulary of classicism. Indeed, his thesis was that contemporary classicism was not only "creative, but that it has an underlying affinity, real though not obvious, with the progressive work in modern painting and the other arts."[18]

Kimball argued that there were two poles of modernism: first, the functional or scientific, objective and realistic; and second, the formal or aesthetic, symbolic and abstract.[19] Furthermore, Kimball concluded that in painting and in architecture alike the formalist approach had triumphed. Kimball defined the Realists and Impressionists in painting and the func-

tionalists in architecture, such as Louis Sullivan, as artists of the scientific approach, artists who "all seek characteristic beauty through truth to nature, rather than abstract beauty through relations of forms."[20] However, Kimball relegated this "scientific school" to the nineteenth century. "There began a reaction even before 1890," argued Kimball, "against this domination of art by science, this equation of beauty with truth."[21] He cited Cézanne as the leader of the formalist reaction in painting.[22] "The counterpart in architecture," he believed, "has been a renewed interest in unity and simplicity of form,"[23] induced because:

> In their narrow search for truth to nature, for expression of use, and structure, too many of the impressionists and functionalists lost all form.[24]

Because of his belief, Kimball viewed the decade of the 1890s as the crucial turning point in the development of modern art and architecture and defined it so in his book. He also judged Louis Sullivan to be, "instead of the forerunner of the new century the last great leader of the old."[25] Paradoxically, this assessment came just at the point when Sullivan's reputation was beginning to be revived by a new generation.

The fact that Sullivan died in 1924 at this auspicious moment served to stimulate interest in him. Furthermore, his negative view of the Renaissance revival that had been introduced by the 1893 Fair was to be found in his *Autobiography of an Idea* which appeared posthumously in 1924. The tone and timing of Sullivan's assessment proved to be so propitious that the reverberations are still being felt. Even abridged, this indictment was vitriolic and devastating.

> The virus of the World's Fair . . . began to show unmistakable signs of the nature of the contagion
> Thus Architecture died in the land of the free and the home of the brave, – in a land declaring its fervid democracy, its inventiveness, its resourcefulness, its unique daring, enterprise and progress. Thus did the virus of a culture, snobbish, and alien to the land, perform its work of disintegration; and thus ever works the pallid academic mind, denying the real, exalting the fictitious and the false, incapable of adjusting itself to the flow of living things.[26]

Although these words were written thirty years after the Fair, and in the bitterness of the unpopularity and neglect of Sullivan's later years, 1924 turned out to be an important moment in the increasing sentiment against historical precedent and toward progressive architecture, and so they had a tremendous impact. From this point onward, the modernist view of Sullivan began to develop and grow into a legend.[27] For example, when he came to write *The Story of Architecture in America* in 1927, architect and critic Thomas Tallmadge discussed Sullivan and what he called the rationalist ideals of the Chicago architects under the heading of a "Lost Cause."[28]

By 1936 and the second edition of his book, Tallmadge rewrote the chapter and retitled it accordingly, "Louis Sullivan, Parent and Prophet."[29] Indeed, the increase in Sullivan's reputation and the reevaluation of his proper position in the history of architecture is a significant indication of the crucial changes which were taking place in the American evaluation and acceptance of modernism. In 1928, even Edgell placed Sullivan among the modernists, that it, akin to the European avant-garde.[30]

It must be acknowledged, moreover, that none of the conservative authors ignored the developments surrounding the controversial designs of the commercial tall buildings in late nineteenth-century Chicago, although a later generation would assume they did. Both Edgell and Kimball provided thorough and perceptive treatments of this phenomenon, which included Sullivan and which Kimball called functional architecture, even if in the end they remained unconvinced of the lasting value of these more original contributions. The fact that the Chicago phenomenon commanded so much of their attention is, in the final analysis, a strong indication of how insistent the advanced attitude was becoming, and the degree to which the conservatives were on the defensive.

When they were published in 1928, Edgell's and Kimball's books proved to be, in fact, the last serious efforts to defend historical architecture. Kimball himself recognized that an important alteration in attitude had occurred and was still underway since he had first addressed the issue of modern architecture in 1924. Therefore, when he wrote the chapter on "The Present" in *American Architecture*, he noted: "The established order, the supremacy of classical form continued Nevertheless, it is threatened.[31] Chief among the threats he listed the antihistorical influences from Europe. "Certain American artists have recognized," he wrote, "the creative liberty secured by the Germans, and are trying to free themselves from the bondage of academic detail."[32] The second "impulse from abroad" which he noted was the impact of the 1925 Paris Exposition of Decorative Arts and which he believed was responsible for the enthusiasm for modernistic detail and decoration.[33]

At the same time, Kimball also noted two American developments. The first he described as the general American tendency toward experimental eclecticism.[34] A colleague, Talbot Hamlin, recognized the same leaning and called it, "stylistic freedom . . . the comparative unimportance of the entire question of style correctness."[35] Both seemed, in fact, to be referring to the gradual breakdown of the absolute authority of historical precedent caused by the new eclecticism of the last two decades.

The second American development that Kimball discussed was the impact on design caused by the zoning ordinance enacted in New York City in 1916. Like nearly everyone else at the time, Kimball considered this development to be one of the most impressive American architectural advances of the decade. Specifically, he felt that the demands of the regula-

tions had encouraged a return to the aesthetic "sculpting of mass"[36] in the design of the tall building, and was impressed enough to admit that "the tall office building with steel frame is again in the center of interest."[37]

Regulations for stepping back or setting back the mass of a building at a certain point above the street were prescribed in the 1916 New York City zoning ordinance,[38] in order to insure that adequate light and air would reach all areas of the skyscraper as well as the street itself. The dramatic shapes that characterized the multileveled skyscrapers of the 1920s were due to an unparalleled architectural response to the legislation, a response initiated and developed by an architectural renderer, Hugh Ferriss. Ferriss, who had trained as an architect, nevertheless found that his greatest talent and interest lay in rendering. He produced one of his most enduring works in an early project in which he illustrated the effects of the zoning ordinance for a 1922 *New York Times* article (fig. 17); Ferriss's pyramid-hewn-into-palisade conception of the set-back skyscraper was so compelling that it become the prototype for a new American skyscraper style, as well as the standard illustration of the law.[39]

The skyscrapers which followed from Ferriss's interpretation of the ordinance were the most conspicuous American architectural development of the twenties, discussed and lauded by conservatives and progressives alike throughout the decade. As George Edgell exclaimed: "The effect of the zoning law, is the most interesting single phenomenon in American architecture to-day."[40] Although set-backs were suggested in the receding buttresses that soared upward in Saarinen's Tribune Competition design and in its progeny, Raymond Hood's American Radiator Building, the Ferriss effect was not full blown until the second half of the decade in such examples as the New York Telephone (Barclay-Vesey) Building by Voorhees, Gmelin and Walker, completed in 1926 (fig. 18), and the Shelton Hotel by Arthur Harmon of 1925 (figs. 19 and 20).

The characteristic set-back skyscraper appeared to be massively three-dimensional. Especially as rendered by Ferriss,[41] its bulk was imbued with an awesome drama; through his skillful manipulation of light, dark and perspective, he suggested buttresses chiseled out of solid rock rising majestically to support a soaring central tower (figs. 21 and 22).[42] This vision of imposing elegance which Ferriss created did not fail to establish, for the skyscraper at least, a new standard of beauty and style based primarily on form, such as described by Talbot Hamlin:

> Adopted purely as a practical measure, it provided a magic wand to set American city architecture free from its nightmare Suddenly a latent form sense and imagination developed; buildings became interesting in outline and silhouette as well as in detail. Romance was born; piled masses soared into the sky No longer was the high building apparently built by the mile and cut off to order, but it was composed, break upon break, buttress on buttress The possibilities of poetry entered in.[43]

Invariably, the supporting steel structures of these skyscrapers were sheathed in masonry. They did not express the skeleton frame; in fact, they reaffirmed the wall with a vengeance. In this regard, the set-back skyscrapers represent a curious anomaly in the development of modern American architecture; interest in greater and greater emphasis on the lightness and openness of the supporting frame, which had characterized the Gothic-styled phase of the skyscraper, was now abandoned.

Significantly, on the other hand, everyone was struck and impressed by the fact that "a restriction, imposed for *purely utilitarian considerations*" had "suggested design" and "made a great architectural asset."[44] Moreover, the decoration of these buildings was kept to a minimum, appearing primarily around entrances, at the termini of the buttresses and on the apex of the tower. Ferriss himself did not endorse any particular decorative scheme, but sought to express "the underlying truth" of the buildings which, not surprisingly, he described as "mass in space."[45] Thus, the architects of the set-back skyscrapers believed that they created their major effect through the abstract manipulation of form, such as Kimball had advocated, yet, at the same time, responded to function.

Americans, moreover, found the set-back skyscrapers convincingly modern and conspicuously American because of their stylistic innovation. As one enthusiastic critic commented:

> Some beneficent poser, embodied at present in a zoning law, has given architects a chance to create beautiful and appropriate buildings, not Greek temples nor mediaeval cathedrals, but something modern, born of a new spirit which is neither Greek or Gothic nor Roman or classic renaissance, but which is tensely of today.[46]

Although only incidentally expressive of their structure, the set-back skyscrapers were, in fact, a significant aspect of the development of modern American architecture.[47] They reflect one way in which design based on abstract form, shape and mass relationships, rather than volume and structure, was evolving into a modern idiom.

After 1924 it began to become apparent that the perceived authority of historical precedent was being undermined by those who practiced or professed modernism. The argument for a suitable original expression of the unprecedented dynamism of the modern age was growing irresistible. Fiske Kimball had sensed the challenge, and had written a final defense of the conservative position. One young journalist was most effective in promoting the idea of a thoroughly modern architecture, and most direct in challenging Kimball. Lewis Mumford first became involved in architectural issues around 1924 through his concerns about cities and urban conditions; he was prolific, outspoken and impassioned, and he began by challenging the architectural establishment.[48] As he wrote in an early article in 1924:

What is called Renaissance architecture today has nothing to do with the original Renaissance movement; it is merely characteristic of our dreadful facility in imitation, and it expresses the willingness of even the architect in a machine age to accept a pattern for cheap reproduction instead of undergoing the abysmal labors of creative design.[49]

Mumford may have been young and relatively inexperienced in architectural matters, but his voice was raised at the right moment and with the most timely criticisms. He attacked the traditionalists where they were most vulnerable, calling them imitators without creative consciousness or commitment. Where Kimball saw the contemporary classical as a restoration of aesthetic essence, Mumford called it "veneer,"[50] "insincere and imitative,"[51] an "Imperial Facade."[52] Mumford discussed his negative assessment of the contemporary classicism at some length in his 1924 study of American architecture, *Sticks and Stones*. He did allow that "the age shaped" the architects of the American Renaissance,[53] but he also chided, "Unfortunately, the architecture of the Renaissance has a tendency to imitate the haughty queen who advised the commons to eat cake."[54] Mumford considered the style thoroughly anachronistic in the present. "When it came face to face with our own day," he wrote, "it had little to say, and it said it badly."[55]

Ironically, at this point, Mumford was basically unacquainted with Louis Sullivan, his ideas or his works. He was aware of the rise of the skyscraper and the importance of skeletal construction which he associated with "The Age of the Machine."[56] But he did not yet associate them with Chicago and he did not discuss Sullivan or any of the other architects of commercial buildings in *Sticks and Stones*. In fact, he was antipathetic towards the steel-framed skyscraper: "In the bare mechanical shell of the modern skyscraper there is precious little place for architectural modulation and detail; the development of the skyscraper has been toward the pure mechanical form."[57] Indeed, there are more than slight echoes of Montgomery Schuyler in this and other opinions offered by Mumford at this time.

However, given his initial rejection of the classical styles, Mumford reacted quickly to the growing modernist mood. By 1928, he had rectified his earlier omission and adopted Sullivan, Root and Wright as the source and inspiration for a new architecture. In that year he first wrote about the emergence of "new energies" to thrust off what he considered the pall of eclecticism:

For a whole generation, from 1890 to 1920, the energies of American architecture worked under the surface

The energies that worked below ground so long are now erupting in a hundred unsuspected places; and once more the American architect has begun to attack the problem of design with the audacity and exuberance of a Root, a Sullivan, a Wright.[58]

Indeed, this was the source and the beginning of the conventional view that the period in American architecture after 1890 and until roughly 1930, had stifled any really creative and progressive elements.

By 1928 Mumford was ready to outline a series of attributes for the architecture of the future that anticipated some of Hitchcock and Johnson's strictures for using only modern materials and expressing them directly.[59] Moreover, Mumford was also well aware of the avant-garde architects, whom he often quoted. First, Mumford proclaimed, "It is by utilizing new methods of construction and embodying a new feeling that our modern architecture lives." To emphasize this point he referred to the Europeans: "In Europe modern architects, like Gropius and Le Corbusier . . . have modified or curbed their feelings so as to fit the construction." Continuing the point about the desire to express structure, he also noted, "One part of the modern feeling for form . . . is a positive pleasure that we take in the elemental structure of an object To realize form-in-function, by its clear, lucid expression, is what constitutes the modern feeling." "Le Corbusier," he added, "is right; at least that much must be there."

However, Mumford differed with the Europeans on the important matter of ornament. On the issue of the "machine aesthetic" or stripped architecture, Mumford pleaded, "But we are still human beings, not dynamos or Diesel engines; and there must be *something more*."[60] He argued the need for a "modern ornament." In fact, he felt that the development of this "something more" was to be the great challenge of modern architecture. He even anticipated a "new battle of styles,"[61] that is, modern styles competing for the proper modern expression of "something more." On the other hand, he had no trouble agreeing that the first step to modern ornament was a complete erasure of all earlier historical forms or details.[62] Nonetheless, at this date Mumford's ideal for modern architecture was a "synthesis of the constructive and the feeling elements . . . in the line of that rule Louis Sullivan was seeking."[63] In 1928, Mumford was still talking about choice, about decoration, even about transitional forms. He did not endorse a single program or style, either European or American, although he supported ideas from several.

The continuing debate and the ferment over modernism is particularly apparent in the pages of the January, 1926, issue of *American Architect*. The oldest in the country, this architectural journal was celebrating its golden anniversary and to mark the occasion invited a number of writers to summarize the current state of American architecture.

One of the invited authors traced "Fifty Years' Progress Toward an American Style in Architecture" and found:

> American architecture has led the world in the creation of fabrics looming to the clouds which are of utilitarian value as well as expressions of a daring inventive spirit. American

architecture has triumphed in adapting modern processes, facilities, and materials for building structures to serve the many."[64]

His assessment emphasized qualities which were considered thoroughly modern. On the other hand, this same author found no specific American style as of yet, and suggested, especially for the skyscraper, "some attractive outer garments," in native American style. He recommended Mayan architecture as an appropriate source of modern decoration.[65]

In another article, Royal Cortissoz, a conservative art critic, drew an analogy between the creative vitality of fifteenth-century Italy and the ferment of the past fifty years in American architecture. However, he did not specifically endorse the Renaissance style, although it was obvious that his favorite architects practiced it. Indeed, as a conservative, he diplomatically avoided the whole issue of style and concentrated on individual personalities, saying that style was, in America, "a distinctly personal affair,"[66] and it was the foreign critics who kept pestering for evidence of an "American Architecture."[67]

It is interesting that another contributor, Thomas Tallmadge, who singled out H. H. Richardson, Richard Morris Hunt and Charles Follen McKim as especially significant in the history of American architecture, did not mention Sullivan. On the other hand, he too considered the "[first] great change . . . impending in architecture," to be the "solution of the skyscraper, unbelievably bungled for twenty-five years."[68] Also interesting and suggestive at this date were Tallmadge's comments on the relation of style to architecture: "Architectural style is a garment and like other garments, is subject to fashions which change, if not from year to year, then from decade to decade."[69] Although Tallmadge probably did not intend his remark to be ironic, it is, nevertheless, difficult not to wonder to what extent Americans considered modernism or a modern style as new garments to enhance their architecture.

However, in the next breath, Tallmadge said: "The great thing in our architecture is not the garment, but the body itself, —the plan, the constructions, the solution that it offers of an American program."[70] Once again, it is both interesting and significant to understand that both of these attitudes could and did exist side by side in the minds of many American architects without them sensing any contradiction.

Finally, extremely interesting was Tallmadge's prediction for the future of Ameican architecture: "I think that there is no doubt that the garment that architecture will don during the coming season will be far more original than in the past."[71] Whether or not it was simply a new garment is arguable; nevertheless, Tallmadge was absolutely correct about a drastic change in the appearance of American architecture.

1929 was the watershed year; thereafter, modernism would always be

the most appropriate stylistic choice for American architecture. After 1929 the historical styles disappeared from serious consideration, their authority having been eroded by modernist arguments and the triumph of modernist attitudes. A number of incidents confirm this momentous change. Between 1929 and 1933, the last great skyscrapers of the era were completed, together reflecting the variety of modernist styles accepted in America: in New York City, the Daily News Building, the McGraw-Hill Building, the Chrysler Building, the Empire State Building and the RCA Building, and in Philadelphia, the Philadelphia Saving Fund Society Building. In 1929, the Museum of Modern Art was founded and plans got underway for an exhibition of international modern architecture. Henry-Russell Hitchcock's pioneering study of the historical antecedents of modernism, *Modern Architecture: Romanticism and Reintegration*, was published in 1929. In 1930 Sheldon Cheney's *The New World Architecture* followed, the first wholehearted underwriting of the modern movement by an American. By 1929 the architectural commission charged with designing the pavilions for the 1933 Chicago Fair, the Century of Progress Exposition, had been appointed and had pledged itself to a thoroughly modern and functional Fair. These architectural endeavors in the years immediately after 1929 are, in fact, a final manifestation of the ascendency of modernism in America.

Yet, as Raymond Hood noted about "going modern," "very few people know what [it] really means."[72] There were still a variety of opinions, not all of them well informed. But even among the perceptive and professional, interpretations varied. During this year several voices were raised, not only to affirm modernism, but also to explain what it was.

Hood noted what he felt was the common view of modernism in 1929; significantly it had to do with appearance:

> The *common* conception is that it means a radical *change in the looks of things*, that the time has arrived when precedent and the accepted standards of beauty are all to be thrown overboard, and that with a new philosophy as a base, new standards and wholly *new conceptions of beauty are to be manufactured*.[73]

Indeed, this is very close to what Tallmadge had predicted in 1926. Furthermore, it is exactly what most Americans hoped for, especially if they were going to accept being modern.

Harvey Corbett was one of those concerned about the "Meaning of Modernism" in 1929, and he concentrated precisely on how and why it looked as it did. He had no doubt that America was "in the midst of an artistic architectural change,"[74] in order to more effectively express the modern age. Significantly, however, Corbett concluded that the change meant not only a new theory, but also a new aesthetic. Therefore, the fundamental question he posed for modernism was whether "the architect

[was] ingenious enough to design his building so that it will work success-fully as a machine and, at the same time, be beautiful to look at?"[75] Corbett was now fully committed to modernism, machine idiom and all, because to say otherwise sounded reactionary. But, although he could not yet point to it, he was optimistic that beauty would come in time:

> The new movement in the hands of the men who have an appreciation of form and mass and color and materials is going to produce things which are as fine and possibly finer than anything the world has yet seen, and it will be infinitely more expressive of this time and period, this age and this civilization. It is important to keep our minds open in order to make the most of our architectural opportunities.[76]

Corbett spoke for most American architects who now wanted their architec-ture to be both expressive of the modern age and beautiful, not merely utilitarian.

Interestingly, Corbett mentioned form and mass before materials in his list of the elements appreciated in modernism. A colleague, Louis Leonard, also writing in 1929, had a slightly different interpretation. He considered new *materials* to be at the heart of modernism and the *progenitor of new forms* if one allowed them to develop: "We are now in a transitional period, struggling with the forms peculiar to steel and concrete. Modern architec-ture necessitates that we develop forms that are peculiar to them."[77]

Yet Leonard went beyond asking for the simple and direct expression of these materials; he raised the issues of style and emotion and quoted Frank Lloyd Wright's definition of architecture:

> The business of architecture is to establish emotional relationship by means of raw materials. Architecture goes beyond utilitarian needs. By the use of inert materials and starting from conditions more or less utilitarian, you have established a certain relation-ship, which has aroused the emotions. This is architecture.[78]

Wright and Leonard agreed with Mumford that there must be "something more" to set architecture apart from mere building, to create an art. Although he aknowledged and approved the "sudden break in precedent," and a profound change in materials, Leonard also assumed that, "Style comes later on, unconsciously. Style is unity, a principle, *animating* all work of an epoch."[79] In most cases style represented for Americans the "some-thing more," the sense of beauty or that which inspired emotion, and they looked forward to it in a modern manifestation.[80]

By 1929, the majority of American architects was persuaded by the logic, viability and timeliness of modernism and were ready to espouse many of its aspects. They were not prepared, however, to be radical. In other words, they were not persuaded to abandon what they considered the

basic principles of architecture, or willing to eschew beauty, as they believed certain European modernists were advocating. American architects still spoke of fundamental principles, common to both traditional and modern design.

Leonard explained this point:

> When the materials of construction change, there is *a continuity of the principles* of architecture but not in its form. Modern architecture is, therefore, only *a restatement of the principles* of architecture in new materials.[81]

A preference for continuity and a desire for easily discernible elements of beauty or style ran long and deep in the American architectural mind. What may be called a streak of caution or even pragmatism by some was a characteristic that most Americans of the period used to distinguish their modernism from what they considered the radical, anarchist European programs.[82]

Raymond Hood was, in fact, an exception among Americans in asserting that "The modern movement does not concern itself with looks at all."[83] The essence of modernism, said Hood, "involves a sincere attempt *to be honest*."[84] He explained that while "tempo, rhythm, dynamic symmetry, color discordance, motion, pattern, or the inspiration of the machine" may occur in modern art, "they are incidental and not essential to it."[85] Such aesthetic principles, he maintained, were just, "the same old hypocrisies that the new art is trying to overcome."[86] This was perceived as the extreme view of many European functionalists and Hood was certainly unique among American architects in adopting it. He was one of the few Americans to say he disavowed beauty:

> Today utility leads the way, and although the result may not always send emotional shivers of beauty up the spine, it offers a good substitute in that it satisfies the intellect. The practical elements of a problem are solved before our old friends, — art and beauty, — are given a crack at it.[87]

Raymond Hood's two most significant commissions during this period may be said to reflect this attitude in the sense that both are essentially free from the applied ornament which was so usual in American designs. All of the stories above street level of the sharply stepped-back and striated mass of the Daily News Building, erected in New York between 1929 and 1930 (fig. 23), are free of ornament. Embellishment on the tiered form of the New York headquarters of the McGraw-Hill publishing house, completed later in 1930 (fig. 24), is severely restricted to an "Art Deco" logos at the summit, a streamlined motif around the entrance and the use of blue-green glazed terra-cotta to sheath the supporting steel frame. Such a lack of decoration on the major portion of these buildings would have been quite

conspicuous at the time and would have led most Americans to consider the appearance of the buildings utilitarian, that is, without benefit of art or beauty.

The answer to the question of how strictly the practical elements were served and the influence of art or style forgone, however, reveals that they were not primarily utilitarian designs. The highly particularized shapes and articulation of both buildings is far more dependent on a conscious reference to the evolving traditions of tall building design than on the exigencies of function. Indeed, in the Daily News Building, verticality is emphasized;[88] the soaring uprights are sheathed with white brick and cut across the recessed spandrels paneled in dark red and black terra-cotta. The McGraw-Hill Building, on the other hand, has the horizontal direction emphasized; here Hood treated the spandrels as unbroken bands of blue-green terra-cotta alternating with a continuous ribbon of tinted glass windows at each level. Such an abrupt shift in directional emphasis must have been a primarily aesthetic decision, since both buildings serve their designated functions as office complexes equally well.

Both designs, moreover, conformed to the prevalent American setback form of skyscraper; each represented the culmination of a design configuration promoted by the 1916 New York zoning ordinance. The emphatically vertical Daily News Building was essentially a stepped-back tower: the descendant of Saarinen's Tribune Competition design and the forerunner of the limestone-clad slab of the 1933 RCA Building at Rockefeller Center (fig. 25).[89] The McGraw-Hill form followed the Hugh Ferriss inspired image of a ziggurat or temple: the broad base set back at regular intervals terminating in a high central platform. Therefore, although Hood verbally advocated the severity of the European functionalists, his works were not like theirs; instead, his works were an intriguing and important synthesis of the European utilitarian aesthetic and the evolving American stylistic tradition.

Hood's extreme attitude, although exceptional among American architects, was shared by a number of other non-architects with a special interest in the European developments. Among them was Alfred H. Barr, Jr., the director of the newly founded Museum of Modern Art, and his young associates, Philip Johnson[90] and Henry Russell-Hitchcock.

The founding of the Museum of Modern Art, in the crucial year of 1929, was one of the most significant and consequential events in the early history of modern architecture as well as of modern painting in this country. Its impact on the further development of modern American architecture would be enormous, because one of the first projects undertaken by Barr and his associates was the organization of an international exhibition of modern architecture. The project resulted in 1932 in a seminal show of primarily European modernists as well as in the publication of Hitchcock

and Johnson's influential essay, *The International Style*, both of which helped to promote and achieve the sense of a single preferable form of modernism.

In the foreword to the catalogue of the exhibition, Barr reviewed and implicitly censured the current state of American architecture. Several of his statements are, nevertheless, especially relevant to this discussion as valuable reflections of this period. First, he referred to "a confusion of contemporary architecture," exacerbated by a modernistic or half-modern decorative style," which he believed had developed in this country in response to the Paris Exposition of Decorative Arts, to the "deluge of 'modernistic' decoration from Vienna, Paris, Stockholm, and Amsterdam," and to Saarinen's Tribune design.[91] In his assessment, Barr not only confirmed the existence of a variety of modernistic styles; he also indicated that one intention of the show was to alleviate this confusion. Second, Barr characterized the new American "modernistic style" as, "merely another way of decorating surfaces,"[92] a generalized but not necessarily accurate indictment of the current state of American architecture, but one which would, nevertheless, become the subsequent conventional interpretation. Third, and most interesting as a reflection of these years, Barr admitted that "the lack of ornament is one of the most difficult elements of the international style for layman to accept."[93] Furthermore, and quite ironically, he also admitted:

> Intrinsically there is no reason why ornament should not be used, but modern ornament, usually crass in design and machine-manufactured, would seem to mar rather than adorn the clean perfection of surface and proportion.[94]

Fourth, Barr explained that an exception had been made in order to include the work of Raymond Hood in the Exhibition[95] because, as Barr said, "he seems the most straight-forward as well as the most open of American architects to new ideas."[96] Although his intention was to repudiate current American attitudes and practices regarding modernism in order to promote the "International Style," Barr's comments, in the context of this study, actually confirm the volatile, but nonetheless positive, climate of modernism in American architecture at the beginning of the 1930s.

Finally, Barr made a brief reference in the foreword to another American building included in the Exhibition.[97] The design of the Philadelphia Saving Fund Society (PSFS) Building (fig. 26) was one of the most significant of the period, particularly because of its debt to the example of European modernism. The architects, George Howe of Philadelphia and the Swiss-born William Lescaze, had made a very deliberate attempt to apply fully advanced European forms and methods to a monumental American structure. Howe, in fact, had recently resigned from a prominent firm noted for its traditional designs, in order to pursue a new commitment to

modernism, and Lescaze, who had arrived in the United States from Zurich in 1920, had been trained in avant-garde design and was determined to practice it. The unique aspects of the PSFS, however, were readily apparent to Henry-Russell Hitchcock, who wrote in his assessment of the building for the MOMA exhibition catalogue: "It is the one American skyscraper which is worth discussing in the same terms as the work of the leading architects of Europe."[98]

Hitchcock, however, basically praised the "look" of the building, emphasizing "the application of an aesthetically logical and consistent horizontal scheme of design to the skyscraper."[99] Specifically, he noted: "The tower with its cantilevered facade of rows of aluminum window frames and grey brick spandrels is certainly admirable both as *sound building and excellent architecture*."[100] In comparison with the horizontal scheme of the McGraw-Hill Building, he considered the PSFS the superior design.[101]

The relationship of the PFSF design to European modernism, however, went beyond the horizontal look that attracted Hitchcock; from the inception of the design, George Howe had insisted on an arrangement of forms based on function and on the use of new materials. The final, unprecedented massing of the building definitely realized his original intentions; each distinct functional area of the building is differentiated by its form and material. The ground floor, which was given over to shop space, is banded by continuous show windows and recessed beneath the cantilevered banking rooms on the second and third floors. The office tower is a slab, stepped-back and placed off-center above the curved section of the banking rooms and base. Finally, the utilities for the building are housed in a separate tower behind and perpendicular to the office tower. It is certainly interesting that Hitchcock found this arrangement troubling: "The curving corner of the granite surfaced base for the banking room," he declared, "is awkward in its relation to the general shape of the building and the handling of the elevator tower at the rear at present appears confusing."[102] The PSFS Building, moreover, was designed without applied ornament; the architects created its striking surface effect through the refinement of the materials. Polished charcoal-colored granite covers the base; sand-colored limestone sheathes the verticals; grey brick was used on the spandrels; black brick covers the utility tower; and aluminum window frames complete the sophisticated masonry and metal, matte and gleaming effect.

The purity of the European or International Style forms and theory emulated in the PSFS remains debatable;[103] there is no question, however, that the building represents the most consciously and completely European-based design in the United States at that date. It should be remembered, moreover, that the Europeans themselves did little more than theorize about the design of the tall building; they built no skyscrapers. There were, therefore, no fully resolved European examples for American skyscraper archi-

tects to follow. They had to adapt the basically horizontal European forms and methods to the vertical form of the skyscraper. The PSFS design is, in essence, a remarkable initial synthesis of the European model and the American reality. However, in the American context, the PSFS represents more than the first attempt to directly and wholly apply European modern methods and forms to the American problem of the skyscraper; it is also further outstanding evidence of the considerable knowledge of and commitment to modernism in America well before 1933, particularly and significantly its European forms.

In another architectural landmark of 1929, American authors completed two of the earliest studies of the international aspects of the modern movement: *The New World Architecture*, by Sheldon Cheney and *Modern Architecture: Romanticism and Reintegration*, by Henry-Russell Hitchcock. Cheney's book is less well-known today. However, it contains many interesting parallels with the later *International Style* as well as important reflections of the contemporary American attitude of continuity between tradition and modernism. Anticipating Hitchcock and Johnson's announcement of the appearance of a single coherent style Cheney said:

> I state definitely my belief: (1) that a new mode *is* established, constituting an architectural revolution more fundamental than any in seven centuries; (2) that the principles and methods underlying are nearer to universal than any that have previously governed building art, and that, therefore, this is the beginning of a world-slope, not merely a racial or national phase; and (3) that nothing to be accomplished hereafter in the 'historic' styles known to civilization will really matter.[104]

About the expression of modern materials which Hitchcock and Johnson later called one of the essential principles of the International Style, Cheney exclaimed:

> Honesty, openness, economy, brightness, direct thinking, faith in a new life, consideration of one's neighbors, these breathe in the very air of this experimental 'development,' projected consciously to give the dreamers of new worlds opportunity to crystallize their ideas in *concrete* and *glass* and *metal*.[105]

Cheney also deplored and chastised the dishonesty of the eclecticism of the immediate past. As he described it:

> Eclecticism is the amiable name given to architectural incompetence in the period 1870 1920. Pickers and choosers from older forms of building, disputers of this or that style within the limits if impotency and imitativeness, tasteful roamers, cultured repeaters of other men's architectural phrases — Eclectics! They were so lost in their worship of pilasters and cornices and acanthus leaves that they never emerged into the fields of creativeness.[106]

And Cheney applauded the "machine-austerity" of the undecorated new architecture.

However, Cheney's book was more a chronicle of the variety of modern manifestations than the statement of a coherent historical or polemical approach. His book reflected the flexibility still inherent in the American attitude. Although he eschewed the eclectic past, like most Americans Cheney continued to accept *"transitional* examples between Eclectic practice and a clean-cut, honest Modernism,"[107] that is, an evolution of style rather than a revolution. Moreover, although he wrote about "stripped architecture," style was what he ultimately desired, particularly style through ornament:

> Style is not a sense-provoking garment, a seductive robe, thrown over a structure, but the flower of the structure itself. We cannot, however machine-logical our intentions, live permanently with an architecture negating stylishness, insistently undecorative.[108]

Finally, like any good American, Cheney celebrated the skyscraper:

> The skyscraper, then, is the building that symbolizes the times
> Nor is the skyscraper only *symbolically* typical of today; nowhere else is architecture so perfectly expressive of the wholly new materials.[109]

In spite of its description of a worldwide movement towards modernism, Cheney's book never had the impact of *The International Style*, published only three years later. Cheney's description of modernism and his commitment to it remained quite broad; his attitude was neither polemical nor apocalyptic, nor did he present a concise program for achieving the ultimate modern style. Rather, he confirmed what most Americans already accepted about modernism: that it evolved from many sources and that it had several manifestations.

Henry-Russell Hitchcock's first book, *Modern Architecture*, was a more carefully drawn interpretation, but one that nonetheless rejected the American conception of continuity. As Hitchcock himself later pointed out, and as the subtitle of the study made clear, his basic thesis in this book was to apprehend the *integration*, that is, the fusion of the best of the various revivals with the new science of building in the creation of modern style.[110] Ironically, in this, his first study of modernism, Hitchcock chose to call the integration the *New Tradition*.

Hitchcock discussed the European modernists with insight, but it was his treatment of American architects, specifically H.H. Richardson, and the architects of the early commercial tall buildings in Chicago, which was to have the most far-reaching significance. He included all of them within the New Tradition and for the first time presented a cogent interpretation of the "Chicago School"[111] as a conspicuous and consequential forerunner of

modern architecture. Until Hitchcock deliberately placed them in the context of modernism, these architects had been remembered primarily as part of the nineteenth-century tradition. From then on, however, they would belong to the history of modern architecture and be seen as one of its most important sources.

One of the major consequences, in fact, of the conversion to modernism that took place in this country after 1929 was the subsequent search for American roots of modernism. These were soon found in the rediscovery of the early steel-framed commercial skyscrapers of Chicago. By 1931, for example, Lewis Mumford was able to proclaim:

> The foundations of a new architecture had been laid Between 1880 and 1895 the task and method of modern architecture were clarified through the example of a group of American architects whose consistent and unified efforts in this line ante-dated, by at least a decade, the earliest similar innovations in Europe Modern architecture had its beginning in this period.[112]

Not only were American architects now convinced of the appropriateness of modern styles, they were also becoming convinced that modernism had begun in America.[113]

When American went modern, a shift in style resulted: a drastic change in the way things looked. This change, however, did not initiate an overturning of the essential conceptions and expectations that Americans held about the nature of architecture and its development. Americans still believed that architecture reflected the age and a nation's character; indeed, the nation's character and the age were now clearly seen to demand modernism. They still conceived of a continuous but evolving relationship with the past, as for example in the discovery of the roots of modernism in Chicago and the insistence that certain basic principles such as beauty remained viable. Even after 1929, Americans continued to seek beauty in external appearances and they desired and made assurances that modern architecture would eventually create a new beauty in the "looks of things." It is indicative of the strength of this American predilection that Hitchcock and Johnson were also compelled to consider "whether . . . the contemporary style will in time develop an ornament of its own as did the styles of the past."[114] Precedent had convinced Americans, even these converts to European modernism, that ornament was a natural attribute of architectural style and they looked forward to its development in modernism, in order to, in their view, complete the style.

At no time, however, did Americans reject the design challenges of new structures, functions and materials, although the majority chose to work gradually toward new solutions within a framework based on tradition. The problem of an optimum design for the skyscraper with its inherent contradiction of tradition, on the other hand, eventually led American architects

and critics to a broad and tolerant formulation of modernism: the accept-
ance of several modernist styles including those based on European exam-
ples. The last pre-World War II skyscrapers, particularly the Daily News
Building and the McGraw-Hill Building indicate the presence of a nascent
American modern style; the PSFS Building proves a contemporary response
to the example of the European modern idiom. Together these buildings
reflect attitudes and conceptions which suggest that nothing Hitchcock and
Johnson argued for in the *International Style* was new to their American
audience. The issues of modern styles had already been debated and the
development of American modernist styles was well underway before 1932.

6

A Most Appropriate Style

The fair stands as a symbol of the architecture of the future – the icons
of the past cast aside.

Harvey Wiley Corbett, 1933

When Lewis Mumford characterized the years between 1893 and 1933 as "a
barren wilderness of classicism and eclecticism,"[1] he was mistaken. When he
suggested that "the continuity of American architectural tradition was bro-
ken," and had failed to advance "solidly toward modern forms,"[2] again, he
was mistaken. The continuity of American architecture was intact; and
modern forms had been evolved through the very practice of classicism and
eclecticism, although Mumford may be excused, in 1933, for assuming that
it was not supposed to happen that way.

Mumford had been prompted to make his observations in anticipation
of the architecture at the Chicago World's Fair of 1933, the "Century of
Progress Exposition," and although Mumford could not like it, the archi-
tecture at this fair bore the fruits of America's four-decade-long evolution
to modernism. It proclaimed to the world America's complete commitment
to modern architecture (fig. 27).

The 1933 Fair had no choice but to be modern. It began and continued
as a self-conscious architectural endeavor. First of all, the spectacular suc-
cess and influence of the architecture at the 1893 World's Columbian Expo-
sition had not been forgotten and the memory placed considerable pressure
upon the organizers of the new Fair. The "White City" of 1893 had been
among Chicago's proudest moments, so that the organizers and architects
of the new Chicago Fair felt a strong compulsion to equal, if not exceed, its
architectural popularity and significance. In fact, the organizers of the 1933
Fair exploited the connection between the two fairs in several ways.[3] Fur-
thermore, the architectural critics had also not forgotten the impact of the
earlier fair and there were constant allusions to its results in the pre-fair
press. Lewis Mumford was one who reminded everyone:

The World's Fair at Chicago in 1893 had a powerful influence upon American Architec-
ture and city planning: it became a model and a goal for aspiration. In the project for

another World's Fair at Chicago in 1933 *a heavy responsibility* lies upon the organizing committee and the architects they have designated to create the buildings. Have the designers enough historic sense to remember the critical blunders of 1891? Have they a sufficiently serious conception of the role they are called upon to play?[4]

The organizers and architects were fully cognizant of their situation and although they considered part of their responsibility to be an emulation of the 1893 Fair rather than the repudiation implicit in Mumford's warning, Mumford need not have worried. The organizers and architects never considered repeating the traditional architectural forms of 1893. They looked forward, together with the American public, to the new fair "as a symbol of the architecture of the future—the icons of the past cast aside."[5] They conceived of its creation by "the ingenuity of designers of the present . . . strengthened only by the background of scientific engineering and inventive genius."[6] No one considered anything but modern styles. As one commentator in the *Saturday Evening Post* wrote:

Could anything be more truly incongruous and absurd than an architecture for this exposition reaching backward instead of forward That would broadcast to the world a confession of the utter impotency of modern architectural art.[7]

The designers of the new fair, wrote another observer, would not be inspired by "romantic dramas," but by reality, by "blue-steeled determinism and cold, white logic."[8] Progress was the slogan of the fair, science and modern technology were its major themes,[9] and modern architecture, everyone agreed, was the only logical expression of these.

In addition, the reputations of recent European fairs had established an association of architectural innovation and experimentation with these events. The critical acclaim of, especially, the Palais des Machines and Eiffel's Tower from the 1889 Paris Exposition, the lavish modernistic design at the 1925 Paris Exposition of Decorative Arts, and the avant-garde spectacle of the German Pavilion[10] at the 1929 Barcelona World's Fair, were all well known to the American designers of the 1933 Chicago Fair. They were well aware that America had not yet created a modern fair. Therefore, at the same time that the Americans were choosing the only logical and appropriate style for the new fair, they were also reacting to a challenge from abroad. As Harvey Corbett, chairman of the Fair's Architectural Commission, explained in 1933, he hoped that the architecture of the Century of Progress would turn the eyes of Europe to America.[11]

The Century of Progress Exposition could never have been anything but modern because Americans, the organizers, the architects, and the public, perceived that modernism was the only choice. Modernism was not only accepted in American architecture in 1933, it was also expected.

An eight-man Architectural Commission, patterned after the memora-

ble 1893 panel of architects, was selected to develop the designs for the new fair. All of those named were prominent, established and highly respected in the profession.[12] Raymond Hood, Harvey Corbett and Ralph Walker, all from New York, were renowned as designers of skyscrapers. Paul Philippe Cret, from Philadelphia, one of the first named to the Commission, was the most widely admired Beaux-Arts educator in this country,[13] but he also had the reputation of being progressive and open-minded as well as demanding. Indeed, all of the members appointed to the Commission were generally considered to be progressives, although Hood and Corbett were definite converts to modernism.

Meeting for the first time early in 1928, the Commission endorsed the expectations for modernist architecture at the Fair. More interestingly, they also reflected, in their statement of intentions, the particular American conceptions of modernism as they had evolved over the past four decades. As their statement revealed, the Century of Progress was to be a thoroughly American enterprise:

> The architecture of the building and of the grounds of the Exposition of 1933 will illustrate in definite form *the development* of the art of architecture *since the great Fair of 1893, not only in America but in the world at large. New elements of construction*, products of *modern invention and science*, will be factors in the architectural composition
>
> The architecture of the world is undergoing *a great change*. It has shown those signs that indicate the birth of a great fresh impulse. The architects of the Chicago World's Fair Centennial Celebration of 1933 intended that the buildings of the fair shall express the *beauty of form and detail* of both the national and the international aspects of this new creative movement.[14]

Consciously or not, in this declaration, the Commission presented American conceptions; they conceived of modern architecture as an unbroken development since 1893, they considered it pluralistic, incorporating a variety of styles, both American and international, they associated it with new construction, materials and science, and they meant to express it as beautiful, using new forms and new ornament. The Fair was conceived in the American mode of modernism, and presented an actual manifestation of this particular understanding in the finished pavilions.

The individual pavilions of the Fair exhibited another particularly American aspect of modernism. Although each pavilion or building group at the Fair was highly individual in plan, elevation and decorative scheme, they had in common great expanses of surface with extraordinarily few windows. Attention to surface or wall mass dominated all of the pavilion compositions; these structures did not evidence much expression of volume. Some emphasized flat, thin, rectilinear surfaces, often painted in contrasting colors, suggesting the shifting planes of cubism, as in Corbett's General

Exhibits Group (fig. 27) and Bennett and Brown's Dairy Building (fig. 28). Others, such as Hood's Electric Building (fig. 29) and Cret's Hall of Science (figs. 30-33), emphasized the plastic quality of surfaces, some of them curving and rounded at the edges, some textured, carved, patterned or colored, enhancing the sense of mass rather than plane. Furthermore, most of the ground plans were asymmetrical, creating a complex two-dimensional scheme, which was, in turn, reiterated in the third dimension by ramps, stepped-back walls and parapets, multileveled terraces and mez-zanines and tall pylons and towers placed off-center to focus the irregular compositions.

Functional concerns were closely associated with the formal results in the minds of the designers. Of course, by this date, the notion of functional-ism, particularly the kind associated with utilitarian factors, was considered a thoroughly modern conception.[15] The organizers and designers of this Fair invoked it liberally and justifiably. They indicated, in fact, that the asymmetrical plans as well as the lack of windows were direct responses to function. Argued the designers, the multiple purpose demands of exhibition space required the greatest flexibility, hence the choice of asymmetry and continuous exterior and interior walls with controlled artificial lighting. A.D. Albert, the Secretary to the Exposition's Board of Directors described with some pride how other functional, technological and economic demands combined to effect the choice of materials and therefore, the ultimate modernity of the composition:

> They are honest, functional buildings. They are what they appear to be—exhibit struc-tures. They have been built on as economical a scale as possible consistent with safety
>
> Inside and outside these buildings are twentieth century creations. For the most part they have been built for fifteen cents a cubic foot or less They are constructed of modern materials—asbestos cement board, sheet metal, gypsum board and plywood. Savings have been accomplished that may suggest important applications to the future of the building industry. Many of the buildings are windowless and lighted artificially. This departure was governed by a desire for economy, and to insure control of the volume and intensity of light at all times, and under every atmospheric condition.[16]

The Fair organizers and designers were made especially sensitive to the use of mundane, low-cost materials and construction by fiscal cut-backs which were imposed during the planning process as a result of the severe economic depression which developed after the 1929 stock market crash.[17] However, these restrictions were consistently treated as assets, even to the extent that functionalism was suggested as a substitute for aesthetics, such as in the comments made by a member of the Department of Works at the Fair:

> Economy was to be achieved by developing materials and assemblies of materials requir-ing a minimum of field work for erection The simplest and most inexpensive

machine production led to units of flat surfaces. Hence the architectural characteristic of the buildings is walls of flat surfaces, with mass effect rather than detail ornamentation in three dimensions

The necessity for high salvage value was a determining factor in the selection of construction details which permit easy disassembly. Steel and timber skeleton framework, with prefabricated unit deck and wall covering, was decided upon.[18]

The best modern spirit of functionalism may have insured severe forms to begin with, but the economic and technological exigencies were everywhere countered by modernistic ornament and detail in a truly American quest for beauty. Streamlined striations, panels of incised chevrons, zigzags or sunrays, *moderne* lettering, flutings, projecting horizontal fin-like ledges, curving walls, chrome banisters and highly stylized, low-relief sculpture spread across the surfaces of nearly every pavilion, and dazzled the eye. Even where broad expanses of wall were left free, they were often brightly colored or abutted and trimmed with decorative panels. Drawn from a variety of sources,[19] this extensive use of modernistic decoration was the second particularly American characteristic of modernism presented at the Fair.

There is little doubt that the extensive use of decoration was, for some, the best attempt to insure beauty under the severely circumscribed economic circumstances. Paul Cret, for one, was dismayed by the utilitarian restrictions. Describing his own design for the centerpiece of the Fair, the Hall of Science, he wrote:

There is very little "architecture" in [it], at least in the sense that Ruskin gave to the word in his "Seven Lamps." The outside walls shamelessly confess that they are built on a thin veneer . . . like fish scales or armor plates

They do not attempt to suggest the mass stability of masonry walls. They hope to get from . . . sculpture; from . . . color, and from . . . planting some of the charm which they lack.[20]

The unusual circumstances of the 1933 Fair, which on the one hand imposed strict utilitarianism with apparent enthusiastic endorsement, but which on the other hand inspired a profusion of applied decoration, seem to represent a contradiction. In general, however, American architects continued to conceive of structure and function as distinct from beauty.

Many Americans had resisted the elimination of the wall which for them embodied the sense of gravity and weight which was for so long a traditional expectation in architecture. They resisted the modern imperative of expressing skeleton structure, arguing that that was not the only or ultimate manifestation of modernism. They maintained a predilection for ornament, considering that decoration implied beauty, the something more that distinguished architecture from building. They also believed that decoration was the manifestation of style, that which resulted from the conscious desire for distinction and beauty in design; and so, from the surface,

from the ornament, they sought the confirmation of a new style, the confirmation of a new architecture. Lewis Mumford was not incorrect when he alleged that American modernists "ha[d] not given up the habit of superposition."[21] But, he was insensitive when he implied that their modernism was merely superficial. Hitchcock and Johnson were not wrong when they suggested that, "Most American architects would regret the loss of applied ornament and imitative design."[22] But they overlooked the careful evolution of American modernism in their judgment that, "to the American functionalists, unfortunately, design is a commodity like ornament."[23] The preference for a sense of mass, and the continued use of applied decoration may be considered an outgrowth of the deeply ingrained American reliance on precedent, which in the designs of some American architects achieved a commendable synthesis of precedent and modernism, of structure, function and external elaboration, and form manipulation. This synthesis is especially apparent in the stepped-back skyscrapers of the late twenties and early thirties. It is also suggested in several of the less elaborate Fair pavilions, such as the Dairy Pavilion, the General Exhibits Building, the Chrysler Motors Building, and the Ford Motor Company Building.[24] Otherwise, the major Fair pavilions only served to emphasize the American concern for surface appearance, which is usually translated into elaboration of form and detail.

The emphasis on wall and mass rather than on volume, and the use of applied modernistic decoration are the two characteristics of the architecture at the 1933 Fair which stood in greatest contrast with European modernism, both as it was presented by Hitchcock and Johnson and as later portrayed in the conventional view of modern architecture. They are also, quite likely, the major reasons why the Fair has not been considered more seriously in the history of modern American architecture. However, both elements were, as we have seen, part of a continuing tradition of aesthetic preference in this country. But if American architects usually conceived of structure and function as separate from aesthetic concerns and decoration, they never meant them to be incompatible. In fact, the entire pursuit of modernism in American architecture may be seen as the reconciliation of the two, that is, the synthesis of modern technology and beautiful form.

In this respect, the intentions behind Sullivan's design for the Wainwright Building, Cass Gilbert's choice for a Gothic sheathing for the Woolworth Building, and Raymond Hood's exploitation of steel, glass, blue terra-cotta tile and modern typography for the McGraw-Hill Building have much in common. They suggest, moreover, a unique American tradition of modernism: the beginnings of a style developing distinctive formal and decorative characteristics.

7

Conclusion

It should be clear that by 1933 American architects had evolved a firm commitment to modernism in architecture and had been engaged for several years in a serious attempt to define a modern style. Moreover, by 1930 these endeavors had materialized into several important building designs, particularly the work of Raymond Hood in New York City and George Howe and William Lescaze in Philadelphia. These designs suggest that two distinct influences were at work in the development of American modernism at this time: the first and most pervasive was American skyscraper design, which had evolved out of the eclectic tradition of the past half-century; the second was European avant-garde functionalism. In the work of Hood and Lescaze and Howe these two influences came together but from different directions. In Hood's work skyscraper design is modified by his understanding of European functionalism, whereas in the PSFS Building of Howe and Lescaze, European functionalism is applied for the first time to the tall building. The formal arrangements and details of these works are apparently very different, yet each is a part of a distinctive American variant of modernism: the skyscraper style developed by the fusion of eclecticism and the advancing International Style.

The expression of modernism in American architecture at this time was most fully developed in the design of skyscrapers, but it was by no means confined to that arena. Two of the most conspicuous demonstrations of American modernism, the Century of Progress Exposition held in 1933 and the Museum of Modern Art's International Exhibition of Modern Architecture of 1932, proceeded toward completion almost simultaneously. These events also manifested the same distinct influences. The Exposition architecture derived from many of the same sources that affected recent skyscraper design, particularly "art-deco" ornamentation, while the International Exposition displayed European avant-garde architecture, but as a *style* defined by two Americans.

On the other hand, it is also clear that the International Style eventually eclipsed the nascent American modernist developments. Ultimately, its forms came to be viewed as the most appropriate modern American style

while its tenets were accepted as the essential explanation of modern architecture. Moreover, its precedent influenced a whole generation of architects, historians and critics into believing that all American architecture between the demise of the Chicago School and the advent of the International Style was reactionary and therefore irrelevant. However, the supersedure of the International Style was not immediate, inevitable or necessarily indicative of inherent superiority.

The International Style, in fact, did not appear in the major architecture of America for twenty years following its proclamation by Hitchcock and Johnson; the next full-blown American example of it was the Lever House, a New York skyscraper completed in 1952. This was the first skyscraper commissioned since 1933, at which time the Chrysler Building, the Empire State Building and the RCA Building were all complete. It must be remembered that due to the economic disaster of the Great Depression and the upheaval of the Second World War, there was a twenty-year hiatus of major building in the country. Indeed, it might be argued that this hiatus not only effectively cut short the indigenous skyscraper development, but also provided an important incubation period for the International Style.

The International Style eventually won out because in the twenty years between 1932 and 1952 it captured the imagination and allegiance of the generation of American architects, many of them still in school, who would dominate the next phase of architectural enterprise. There are several reasons for this. The Style, particularly as presented by Hitchcock and Johnson, was complete and unified; they had outlined a cogent program with specific premises, definite characteristics and a sense of historical imperative that was difficult to resist and which satisfied the American longing for a single, coherent and approbated style. The Style gained even greater authority and influence when several of its European masters arrived in this country in 1937.[1] The presence of Walter Gropius and Mies van der Rohe was eventually manifest in actual buildings, but their most significant impact was made through their direct contact with scores of young architecture students at Harvard University and the Illinois Institute of Technology where the masters accepted teaching positions.

Of course it is not possible to say how soon the International Style would have come to dominate American architecture or indeed, if it would have, had it not been for the hiatus of 1932 to 1952 or the immigration of Gropius, Mies van der Rohe and others. By 1952, however, the beaux-arts designers, the early modernists and the old progressives were all gone or discredited.[2] A new generation of architects, more directly affected by the presence of the European masters, had come to maturity and prominence.

On the other hand, no matter how long it did take, or how long it might have taken, for the International Style to become the singular modern American style, there was never any reason to assume that it precipitated a

revolution or reformation. During the period between 1893 and 1933, Americans accepted the use and expression of modern materials; they were prepared for functionalism and glass curtain-walls. Americans had already initiated all of these and debated them and assimilated them wherever they thought them appropriate. Americans were prepared for a great change in the looks of architecture, even if it meant very little beauty. They were resolved to forgo the particular details of traditional styles that no longer seemed relevant to them, in order to, as Paul Cret advised, "focus our attention to some principles of composition, not new to be sure, but somewhat neglected during the past hundred years, such as the value of restraint, the value of designing volumes instead of merely decorating surfaces and the value of empty surfaces as elements of composition."[3] Americans were prepared to be patient and work toward the evolution of "something more": something aesthetic on the stark new surfaces. Americans who were concerned about the looks of things were not oblivious to modern construction, function, materials or the new age; they hoped to reconcile beauty and modernism. Americans who relied on precedent and tradition for their architectural principles were not mere imitators; they believed that change occurred slowly and was informed by the past. Their hopes and beliefs are the conspicuous driving forces in one of the most consequential periods in the history of American architecture: the period from 1893 to 1933, which gave rise to modern American architecture.

When Colin Rowe described the conventional view of the architecture of 1893 to 1933 as a "mythology," he suggested that a serious misinterpretation and misrepresentation had been perpetrated, that the polarization between "eclectic depravity" and "an architecture of high moral tone," was exaggerated.[4] He was, of course, correct; the conventional reading of this period is decidedly biased. If one looks beneath the surface of the myth of "eclectic depravity," one discovers, instead of illogical, immoral or impotent imitation, an architectural development which is both valid and relevant: a development which resulted in a unique American mode of modernism derived from the conjoining of an eclectic approach to style with European avant-garde forms. Because of the peremptory attitude of European practitioners and teachers, it is not difficult to understand why, in the beginning, a myth was created: why it was easy to overstate the actual impact of European modernism in America. But once one recalls and examines the sequence and nature of American developments during this period the myth must dissolve. First, it is important to remember that American architects never rejected the past; they believed in continuity of development and they relied on precedent. In this they were fundamentally opposite to the European avant-garde. Second, one must realize that Americans discerned a variety of European influences as several separate developments. Third, Americans perceived all of these as *styles*: that is, distinctive decorative or

formal treatments of surface. Fourth, Americans appreciated and adapted the European forms because of their blatant "modernistic" look, at a time when modern seemed the only appropriate expression for American architecture. Fifth, Americans considered these several European styles as fodder for the uninterrupted process of creating a unique American style; toward this end, they continued to have faith in an eclectic process and therefore, they never intended to copy any one style directly. For most of the advanced American skyscrapers of the late twenties and early thirties the European influences are confined to surface treatments. The most significant influences on these buildings remained American: the use of a sheathed, skeleton steel frame; the preference for the massive stepped-back forms popularized by Hugh Ferriss; the predominance of soaring verticality in the tradition of Sullivan and Gothic skyscrapers; and the use of applied modernistic decoration. The development of American architecture during this period, centered as it was on the skyscraper, was far more complex than it has been given credit for being. It was much more than a simple matter of translating European theories into an American building type; indeed, it was never this. It had a history of its own that significantly mitigated the European influences and determined the unique form of its culmination. It is a history which, once recovered, is crucial to our understanding of the direction and nature of the subsequent evolution of modern American architecture and ultimately elucidates our present. Without it we can misunderstand ourselves. With it, the history of modern architecture and certainly the history of American architecture attains greater breadth and credibility.

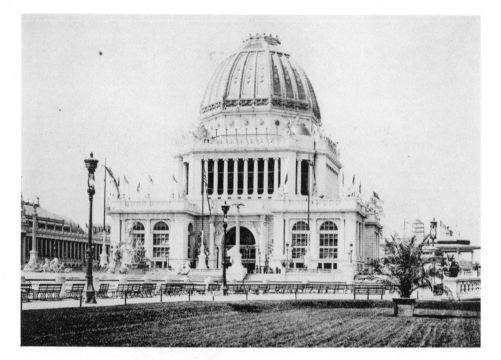

1. Richard Morris Hunt, Administration Building, World's Columbian Exposition, Chicago, 1893 (*Official Views of the World's Columbian Exposition*, Chicago, 1893, Plate 23)

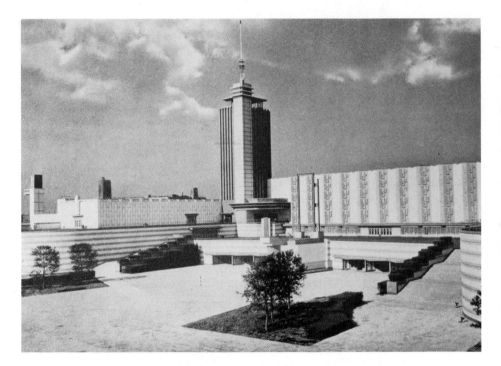

2. Paul Philippe Cret, Hall of Science, A Century of Progress Exposition, Chicago, 1933
 (*Chicago and A Century of Progress*, Chicago, 1933)

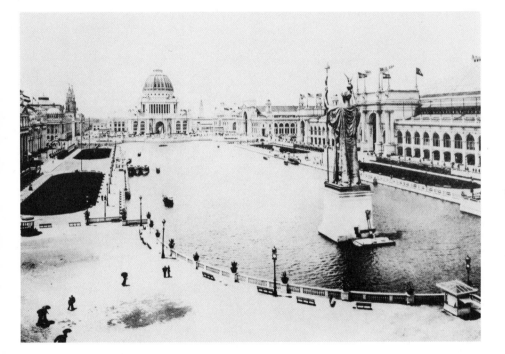

3. Court of Honor, World's Columbian Exposition, Chicago, 1893 (*Official Views of the World's Columbian Exposition*, Chicago, 1893, Plate 15)

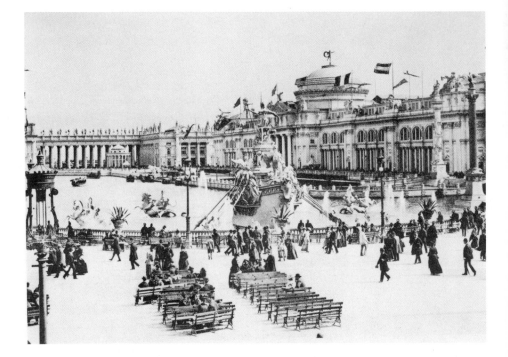

4. McKim, Mead and White, Agricultural Building, World's Columbian Exposition, Chicago, 1893 (*Official View of the World's Columbian Exposition*, Chicago, 1893, Plate 16)

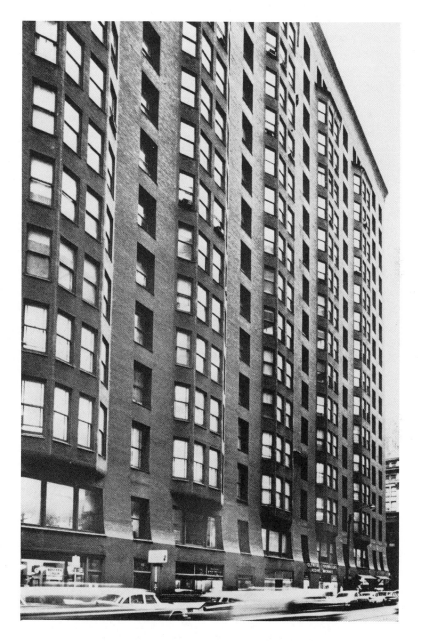

5. Daniel Burnham and John Root, Monadnock Block, Chicago, 1889–92
(Reprinted, by permission, from Donald Hoffman, *The Architecture
of John Wellborn Root*, 1973, Figure 124)

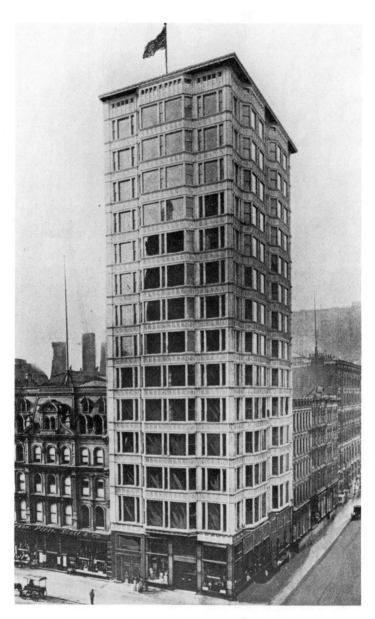

6. Daniel Burnham, John Root and Charles Atwood, Reliance Building, Chicago, 1889–91; 1894–95 (*Architectural Record*, January–March, 1895, p. 305)

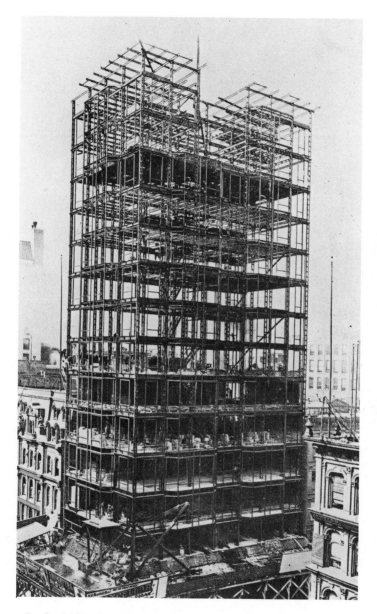

7. Daniel Burnham, John Root and Charles Atwood, Reliance Building
 under construction, 1894 (*Architectural Record*, January–March,
 1895. p. 306)

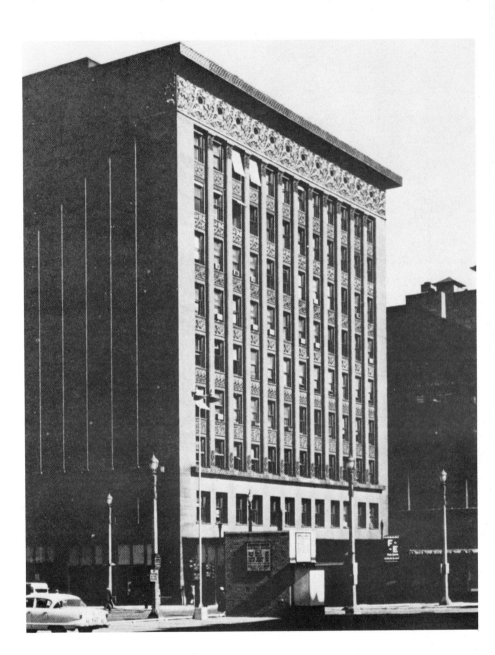

8. Louis Sullivan, Wainwright Building, St. Louis, 1890–91 (Reprinted from Wayne Andrews, *Architecture in Chicago & Mid-America*, 1973, p. 51; photograph) by Richard Nickel

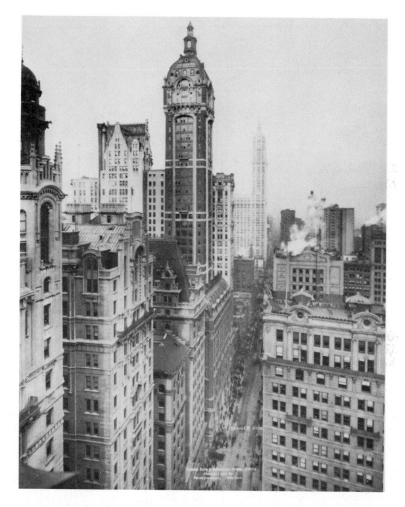

9. Ernest Flagg, Singer Tower, New York, 1908 (Courtesy of The Museum of the City of New York)

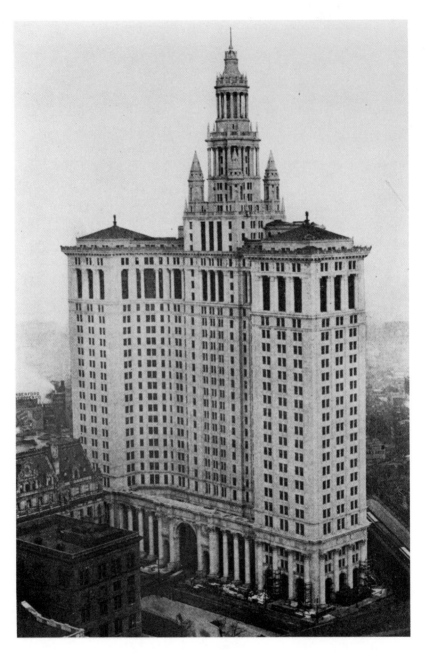

10. McKim, Mead and White, Municipal Building, New York, 1914 (*Architectural Record*, February, 1913, p. 101)

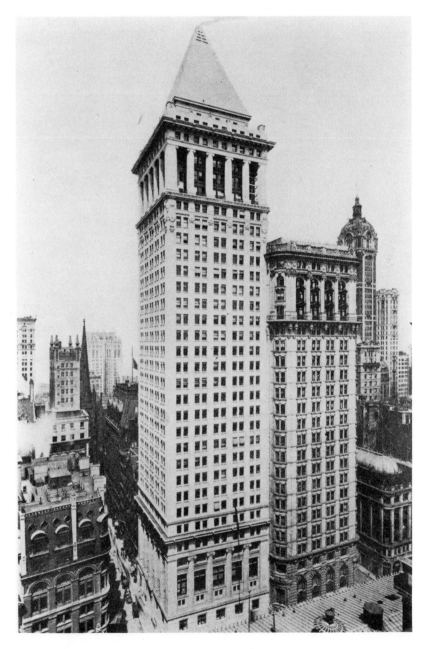

11. Trowbridge and Livingston, Banker's Trust Building, New York, c. 1910
(*Architectural Record*, February, 1913, p. 105)

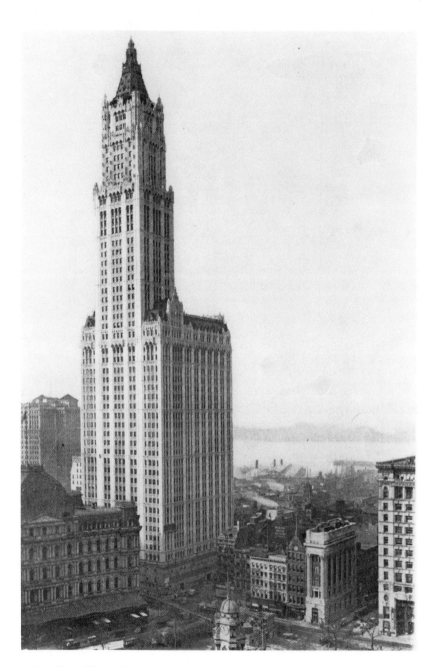

12. Cass Gilbert, Woolworth Building, New York, 1913 (*Architectural Record*, February, 1913, p. 98)

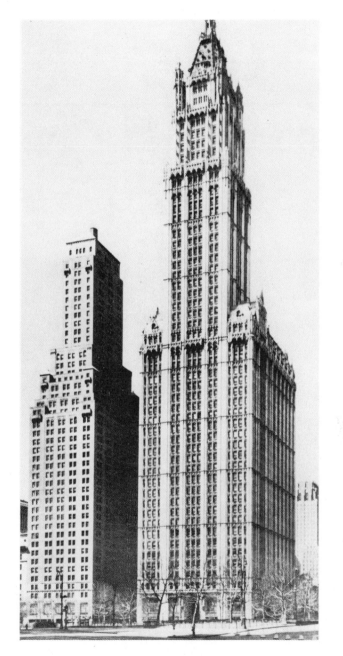

13. Cass Gilbert, Woolworth Building, New York, 1913
(Courtesy of The Museum of the City of New York)

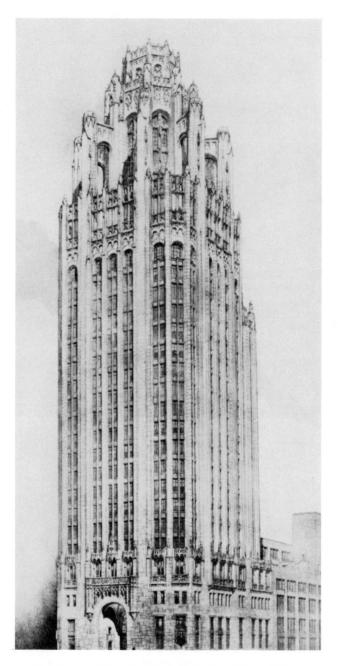

14. Hood and Howells, First Prize Design, Chicago Tribune
Competition, 1922 (*The Tribune Competition*, Chicago,
1923, Plate 1)

15. Eliel Saarinen, Second Prize Design, Chicago Tribune
Competition, 1922 (*The Tribune Competition*, Chicago,
1923, Plate 13)

16. Hood and Fouilhoux, American Radiator
 Building, New York, 1924, Rendering by
 Hugh Ferriss. (Courtesy Avery Library,
 Columbia University)

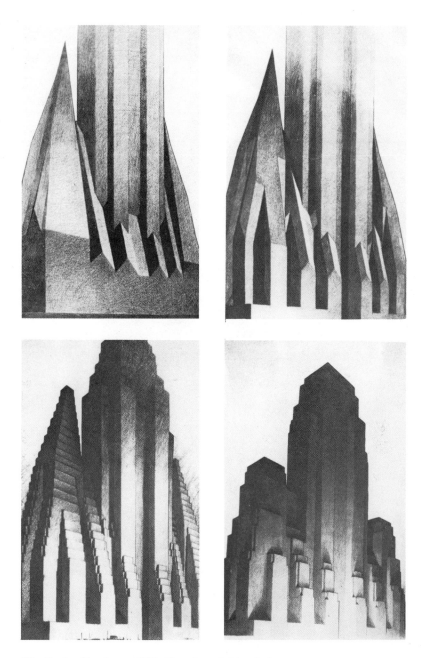

17. Zoning Envelopes, 1922: First through Fourth Stages, Renderings by Hugh
Ferriss (Courtesy of the Cooper-Hewitt Museum, Smithsonian Institution
National Museum of Design)

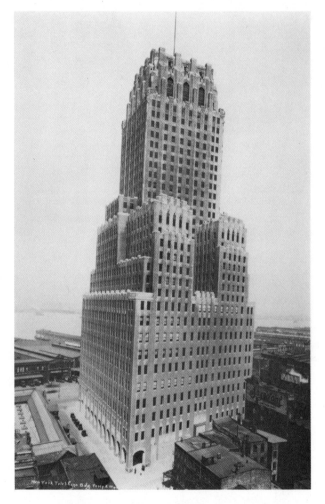

18. Voorhees, Gmelin and Walker, New York Telephone
(Barclay-Vesey) Building, New York, 1926 (Courtesy of
The Museum of the City of New York)

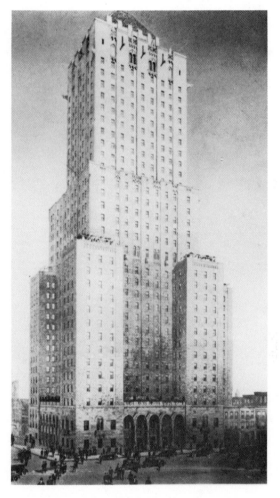

19. Arthur Loomis Harmon, Shelton Hotel, New York,
 1925 (Courtesy of The Museum of the City of
 New York)

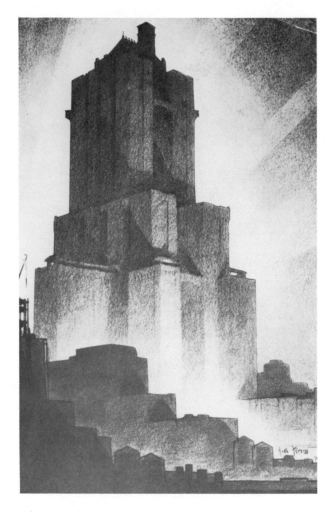

20. Arthur Loomis Harmon, Shelton Hotel, New York, 1925
Rendering by Hugh Ferriss (Courtesy Avery Library,
Columbia University)

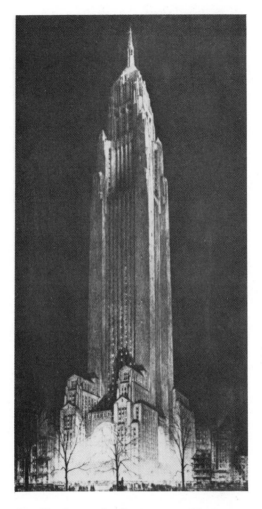

21. The Convocation Tower, proposed by Bertram
 Grosvenor Goodhue, Rendering by Hugh
 Ferriss (Courtesy of Cooper-Hewitt Museum,
 Smithsonian Institution National Museum
 of Design)

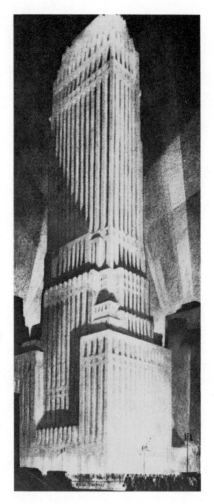

22. Sloan and Robertson, Chanin
Building, New York, 1929,
Rendering by Hugh Ferriss.
(Reprinted from Leich,
Architectural Visions: *the
Drawings of Hugh Ferriss*,
1980, p. 85)

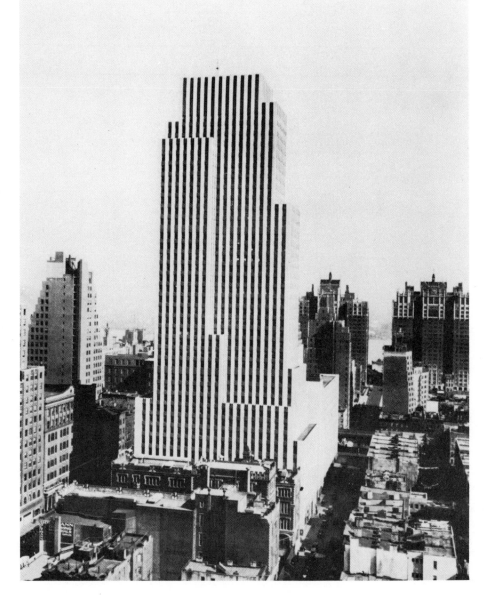

23. Raymond Hood, Daily News Building, New York, 1929–30 (Courtesy of Brown Brothers)

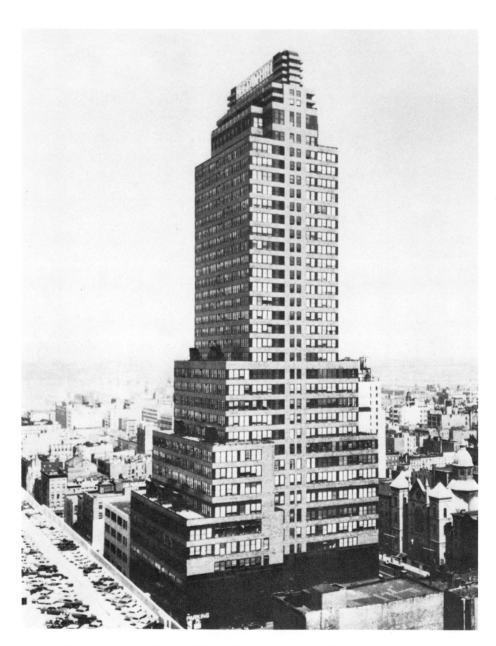

24. Raymond Hood, McGraw-Hill Building, New York, 1930 (Reprinted from Wayne Andrews, *Architecture in New York*: *A Photographic Essay*, 1969, p. 156)

25. Hood, Godley and Fouilhoux, et al., RCA Building, Rockefeller Center, New York, 1931–33 (Reprinted from Andrews, *Architecture in New York*, p. 158)

26. George Howe and William Lescaze, Philadelphia Saving Fund Society Building, Phila-
delphia, 1929–32 (photo © Lawrence S. Williams, Inc.)

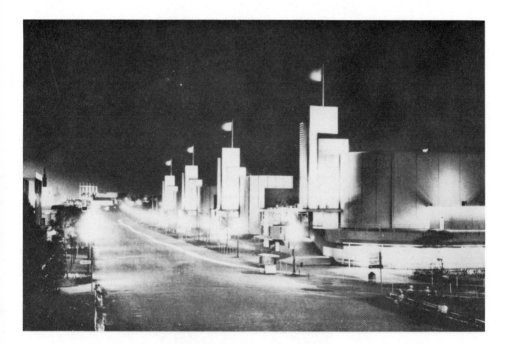

27. Harvey Wiley Corbett, General Exhibits Pavilion, A Century of Progress Exposition, Chicago, 1933, night view (*The Official Pictures of A Century of Progress Exposition*, Chicago, 1933)

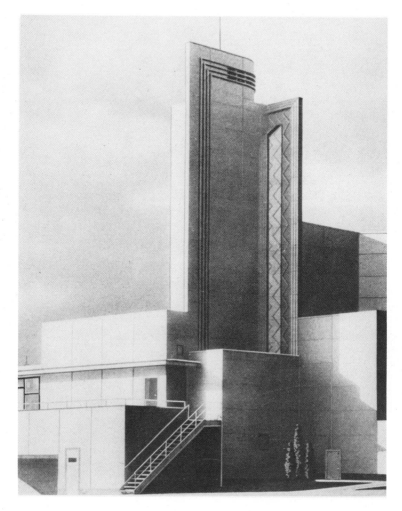

28. Edward Bennett and Arthur Brown, Dairy Building, A Century of Progress Exposition, Chicago, 1933 (*Chicago and A Century of Progress*, Chicago, 1933)

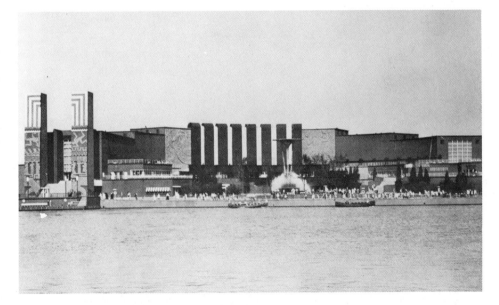

29. Raymond Hood, Electrical Building, A Century of Progress Exposition, Chicago, 1933
(*Chicago and A Century of Progress*, Chicago, 1933)

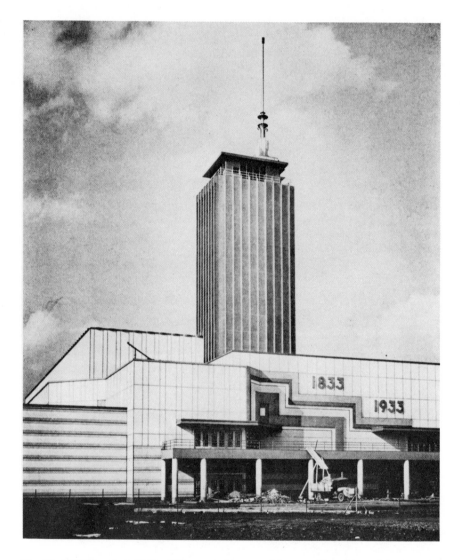

30. Paul Philippe Cret, Hall of Science, A Century of Progress Exposition, Chicago, 1933 (*Architectural Forum*, October, 1932, p. 105)

31. Paul Philippe Cret, Hall of Science, A Century of Progress Exposition, Chicago, 1933; entrance detail. (*Architectural Forum*, October, 1932, p. 106)

32. Paul Philippe Cret, Hall of Science, A Century of Progress Exposition, Chicago, 1933;
 courtyard (*Architectural Forum*, October, 1932, p. 295)

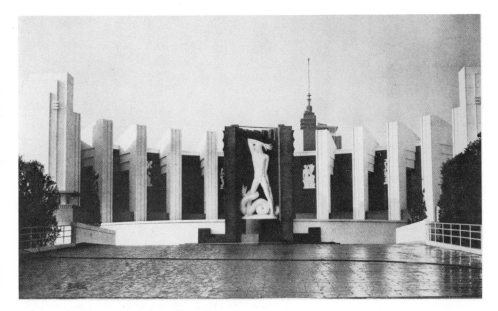

33. Paul Philippe Cret, Hall of Science, A Century of Progress Exposition, Chicago, 1933; North Court (*The Official Pictures of A Century of Progress Exposition*)

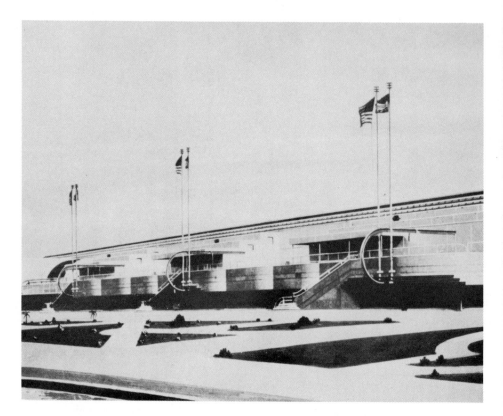

34. Edward Bennett and Arthur Brown, Agricultural Building, A Century of Progress Exposition, Chicago, 1933 (*The Official Pictures of A Century of Progress Exposition*)

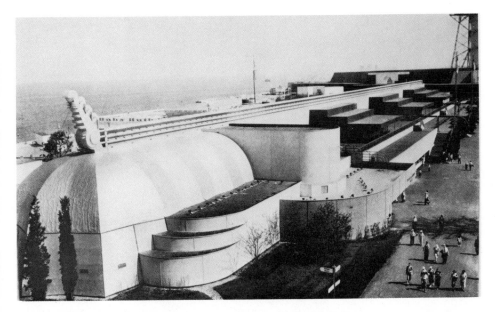

35. Edward Bennett and Arthur Brown, Agricultural Building, A Century of Progress Exposition, Chicago, 1933 (*Chicago and A Century of Progress*)

Notes

Chapter 1

1. Lewis Mumford, "Two Chicago Fairs," *The New Republic*, vol. 65 (January 21, 1931), p. 271.

2. Sigfried Giedion, *Space, Time and Architecture* (Cambridge, Mass.:1941), 5th ed. (1967), p. 500.

3. William H. Jordy and Ralph Coe, "Editors' Introduction" to Montgomery Schuyler, *American Architecture and Other Writings* (New York: Atheneum, 1964), p. 3.

4. Giedion, *Space, Time and Architecture*, p. 500.

5. Almus P. Evans, "Exposition Architecture: 1893 vs. 1933," *Parnassus*, vol. 5 (May, 1933), p. 17.

6. William G. Shepherd, "Fair for Tomorrow," *Colliers Magazine*, vol. 90 (September 17, 1932), p. 10.

7. Philip Johnson held the position of Director of the Department of Architecture and Design for the Museum from 1930 to 1936 and again from 1946 to 1954. *The International Style* was written by Hitchcock and Johnson as a corollary to the exhibition and its catalogue. Moreover, the influence of the Director of the Museum, Alfred H. Barr, Jr., cannot be underestimated and will be discussed later in this study.

8. By 1933 the most severe effects of the Great Depression had taken hold and very little building at all was occurring because of the ruined economy. In 1939, the Second World War began and it was not until the decade of the fifties that the building industry like the rest of the country returned to some degree of normalcy.

9. These include: Chrysler Building, N.Y., 1928–1930, by William Van Alen; Daily News Building, N.Y., 1929–1930, by Raymond Hook; McGraw-Hill Building, N.Y., 1929–1930, by Raymond Hood; Empire State Building, N.Y., 1929–1931 by Shreve, Lamb and Harmon; RCA Buiilding, Rockefeller Center, N.Y., 1931–1933 by Associated Architects including Hood, Godley and Fouilhoux; Philadelphia Savings Fund Society Building, Philadelphia, 1929–1932, by George Howe and William Lescaze.

10. In 1890, two major architectural journals were being published, both established in 1876: *American Architect and Building News* in Boston and *Architecture and Building* in New York. In 1891, four new journals began publication: *Architectural Record* in New York, *Architectural Review* in Boston, *Inland Architect & News Record* and *Western Architect*, both in Chicago. In 1903, *Architecture* began publication and in 1913, the *American Institute of Architects' Journal* was established.

11. Lewis Mumford, *Sticks and Stones*, 1924; Talbot Hamlin, *The American Spirit in Architecture*, 1926; Thomas Tallmadge, *The Story of Architecture in America*, 1927/1936; Sidney Fiske Kimball, *American Architecture*, 1928; G.H. Edgell, *American Architecture of To-day*, 1928; Lewis Mumford, *The Brown Decades*, 1931.

12. Claude Bragdon, "Architecture in the United States," *Architectural Record*, vol. 25 (June, 1909), p. 426.

13. Barr Ferrée, "The High Building and Its Art," *Scribner's Magazine*, vol. 15 (March, 1894), p. 297.

14. Colin Rowe, "Roots of American Architecture: An Answer to Mumford's Analysis," *Architectural Review*, vol. 116 (August, 1954), p. 76.

15. The most influential include: Le Corbusier's *Vers Une Architecture*, 1923; *The International Style*, 1932 by Henry-Russell Hitchcock and Philip Johnson; Walter Gropius, *The New Architecture and the Bauhaus*, 1937; Nikolaus Pevsner, *Pioneers of the Modern Movement*, 1936; Walter Curt Behrendt, *Modern Building: Its Nature, Problems and Forms*, 1937; and Sigfried Giedion, *Space, Time and Architecture*, 1941. Certainly all of them must be drawn upon in summarizing the essential concepts or beliefs that have formed the conventional view of modern architecture.

16. I have used *The International Style* as the major source for my summary of the conventional view, drawing on pertinent material from the other works for amplification or clarification where necessary.

17. Henry-Russell Hitchcock was born in 1903 and graduated from Harvard in 1924. Philip Johnson was born in 1906 and graduated from Harvard in 1927.

18. Henry-Russell Hitchcock and Philip Johnson, *The International Style* (New York: W.W. Norton & Co., 1932), p. 19.

19. Ibid., pp. 17–19.

20. Ibid., p. 29.

21. Thomas S. Kuhn, *The Structure of Scientific Revolutions* (Chicago: University of Chicago Press, 1962), pp. 6–7.

Chapter 2

1. *The International Style* by Henry-Russell Hitchcock and Philip Johnson was originally published in 1932 under the title, *The International Style: Architecture Since 1922*, and written in conjunction with the authors' involvement in the 1932 Museum of Modern Art sponsored exhibition, "Modern Architecture: International Exhibition."

2. Nikolaus Pevsner, *Pioneers of Modern Design* (Harmondsworth Middlesex, England: Penguin Books, 1960), p. 214; this book was originally published in 1936 by Faber and Faber under the title, *Pioneers of the Modern Movement*, and developed from a class on the history of nineteenth- and twentieth-century architecture at Göttingen University in 1930 and a short paper in the *Göttingesche Gelehrte Anzeigne* of 1931. It was revised in 1948 under the auspices of the Museum of Modern Art and again in 1960 for the Pelican edition, which is the edition cited here.

3. In the following year, 1933, Hitchcock and Johnson were involved in another exhibition for the Museum of Modern Art entitled, "Early Modern Architecture: Chicago 1870-1910." In this show they presented the commercial architecture of late nineteenth-century Chicago, most of which were tall buildings, as the predecessors of modern architecture.

4. Ibid., p. 20.

5. Gropius, p. 44.

6. Modern architecture in Europe sprang from an attitude which saw the modern age as a completely new civilization built on the ruins of the old. This encouraged the belief that the new architecture could and would influence the making of that new civilization not only as a formal or aesthetic expression, but, more importantly, as an active agent of social reform. In other words, new, simpler, more honest building would improve the society.

7. Hitchcock and Johnson, p. 80.

8. Alfred H. Barr, Jr., Preface to Hitchcock and Johnson, *The International Style*, p. 13.

9. Ibid., p. 78.

10. Ibid.

11. Ibid., pp. 37–38.

12. Gropius, p. 19.

13. Le Corbusier, *Towards A New Architecture* (Suffolk, England: Richard Clay & Sons, Limited, 1931), p. 3; originally published in 1923 in Paris as *Vers Une Architecture*.

14. Pevsner, p. 210.

15. Ibid.

16. Gropius, p. 19.

17. Ibid., p. 20.

18. Le Corbusier, p. 3

19. Hitchcock and Johnson, p. 20

20. Ibid., p. 23

21. Ibid., pp. 23 and 24; for purposes of context and brevity the original arrangement of paragraphs has been altered.

22. Ibid., p. 23.

23. Ibid., p. 18.

24. Ibid.

25. Ibid., p. 24; the full development of this thesis is contained in Henry-Russell Hitchcock, *Modern Architecture: Romanticism and Reintegration*, (New York, 1929).

26. Ibid. Italics added.

27. Ibid., p. 18.

28. Ibid., p. 24.

29. Ibid., p. 25.

30. Ibid.

31. Ibid.

32. Ibid., pp. 25–26.

33. Ibid., p. 26.

34. Ibid., p. 27.

35. Ibid., p. 26.

36. Many Europeans imbued modern architecture with a utopian aspect related to their commitment to social reform through architecture. They, therefore, deprecated individual expression, as Nikolaus Pevsner explained: "The whims of individual architects, the strokes of genius of others cannot be accepted as an answer to the serious questions which it is the responsibility of the architect to answer" (*Pioneers of Modern Design*, p. 217). Walter Gropius went as far as to advocate standardization of types and forms. He argued for essential form and called for "the elimination of the personal content," as "ungeneric or non-essential features" (*The New Architecture and the Bauhaus*, p. 34).

37. Hitchcock and Johnson, p. 18.

38. Ibid., p. 17.

39. Ibid., p. 19.

40. Ibid., pp. 19–20.

41. Ibid., p. 19.

42. Ibid., p. 21.

43. Ibid., p. 68.

Chapter 3

1. Ernest Flagg, "American Architecture as Opposed to Architecture in America," *Architectural Record*, vol. 10 (October, 1900), p. 178.

2. Bragdon, "Architecture in the United States," p. 426.

3. Frederick S. Lamb, "Modern Use of the Gothic: The Possibilities of New Architectural Style," *The Craftsman*, vol. 8 (May, 1905), p. 150.

4. A.D.F. Hamlin, "Twenty-five Years of American Architecture," *Architectural Record*, vol. 40 (July, 1916), p. 12.

5. H. Harold Kent, "The Chicago Tribune Competition," *Architectural Record*, vol. 53 (April, 1923), p. 379.

6. Lewis Mumford, "Our Modern Style," *The Journal of the American Institute of Architects*, vol. 12 (January, 1924), p. 26.

7. Hitchcock and Johnson, *The International Style*, p. 19.

8. Harvey Wiley Corbett, "The Significance of the Exposition," *Architectural Forum*, vol. 59 (July, 1933), p. 21.

9. F.W. Fitzpatrick, "The Paucity of Ideas in American Architecture," *Architectural Record*, vol. 24 (July-December, 1908), p. 395.

10. Leonard Eaton in his study entitled, *American Architecture Comes of Age* (Cambridge, Mass., 1972), uses this idea to describe the influence of American architects, H.H. Richardson and Louis Sullivan on contemporary European architecture.

11. The notable exception was the work of H.H. Richardson which was considered of unusual excellence at the time and has continued to be ever since.

12. Robert Peabody, "Architecture and Democracy," *Harper's Magazine*, vol. 81 (July,

1890), p. 222. Peabody went on to say: "It is the fashion to believe that art cannot thrive in our trading democracy Indeed, we have lately been told by a professor of great distinction that there is no hope here for real literature or art, so hopelessly vulgar and sordid is American life." While Peabody's professor remains unidentified, the attitudes expressed are similar to those of another professor of "great distinction," Charles Eliot Norton, the first professor art history in the United States and chairman of the Department of the History of Art at Harvard University for nearly a quarter of a century. Norton stated his opinion on the status of art in America in an 1895 article advocating a great commitment to teaching the appreciation of fine arts in this country. Wrote Norton: " . . . nowhere are such study and knowledge [of the fine arts] more needed than in America, for nowhere in the civilized world are the practical concerns of life more engrossing; nowhere are the conditions of life more prosaic; nowhere is the poetic spirit less evident, and the love of beauty less diffused. The concern for beauty, as the highest end of work, and as the noblest expression of life, hardly exists among us, and forms no part of our character as a nation. The fact is lamentable, for it is the expression of its ideals by means of the arts which render those ideals in the forms of beauty, that the position of a people in the advance of civilization is ultimately determined. The absence of the love of beauty is an indication of a lack of the highest intellectual quality, but it is also no less an indication of the lack of the highest moral disposition" (Charles Eliot Norton, "Educational Value of the Fine Arts," *Educational Review*, vol. 9 [April, 1895], p. 346).

13. H.C. Butler, "An American Style of Architecture," *The Critic*, vol. 20 (September 30, 1893), p. 203.

14. Ibid.

15. Bragdon, "Architecture in the United States," p. 426.

16. Thomas Hastings, "Architecture and Modern Life", *Harper's Monthly*; vol. 94 (May, 1894), p. 958.

17. Ibid.

18. Ibid., p. 957.

19. Julian Ralph, "Our Exposition at Chicago," *Harper's Magazine*, vol. 84 (January, 1892), p. 205.

20. Mariana Griswold Van Rensselaer, "The Artistic Triumph of the Fair-Builders," *Forum*, vol. 14 (December, 1892), pp. 527-28.

21. Montgomery Schuyler, "Last Words about the World's Fair," in *American Architecture and Other Writings*, ed. William H. Jordy and Ralph Coe (New York: Atheneum, 1961), p. 287. The article originally appeared in *Architectural Record*, vol. 3 (January-March, 1894), p. 271-301.

22. American novelist William Dean Howells wrote a series of essays recording his impressions of the Chicago Fair, entitled, "Letters of an Altrurian Traveler."

23. William Dean Howells, "Letters of an Altrurian Traveler," *The Cosmopolitan*, vol. 16 (January, 1894), p. 32.

24. Henry Van Brunt was the designer of the Electricity Building which was not, however, located on the Court of Honor.

25. Henry Van Brunt, "Columbian Exposition and American Civilization," *The Atlantic Monthly*, vol. 71 (May, 1893), p. 583.

26. Ibid.

27. Van Brunt, "Architecture at the World's Columbian Exposition," in *Architecture and Society*, a collection of Van Brunt essays edited by William A. Coles (Cambridge, Mass.: Harvard University Press, 1969), p. 233; originally published in several issues of *Century Magazine* (1892).

28. Van Brunt, "Historic Styles, Modern Architecture," in *Architecture and Society*, ed. William A. Coles, p. 303; originally published in *Architectural Review*, vol. 1 (August 1, 1892), pp. 59–61; vol. 2 (January 2, 1893), pp. 1–4.

29. Van Brunt, "The Columbian Exposition and American Civilization," p. 583.

30. Van Brunt, "The Architecture of the World's Columbian Exposition," p. 232.

31. Ibid.

32. Van Rensselaer, pp. 531–32.

33. Van Brunt, "Historic Styles, Modern Architecture," p. 300.

34. Russell Sturgis, "Good Things in Modern Architecture," *Architectural Record*, vol. 8 (July-September, 1898), p. 93.

35. Ibid, p. 92.

36. H. Harold Kent, "The Chicago Tribune Competition," p. 378.

37. Ibid.

38. Claude Bragdon, "Architecture in the United States; Part III, The Skyscraper," *Architectural Record*, vol. 26 (August, 1909), p. 85.

39. George H. Edgell, *The American Architecture of To-day* (New York: Chalres Scribner's Sons, 1928), p. 350.

40. Kent, "The Chicago Tribune Competition," p. 378.

41. Bragdon, "Architecture in the United States," p. 90.

42. Barr Ferrée, "The Art of the High Building," *Architectural Record*, vol. 15 (May, 1904), p. 445.

43. Harvey Wiley Corbett, "The American Radiator Building, New York City," *Architectural Record*, vol. 55 (May, 1924), p. 473.

44. Van Brunt, "Growth of a Characteristic Architectural Style," in *Architecture and Society*, ed. William A. Coles (Cambridge, Mass.: Harvard University Press, 1969), pp. 321–22. The article was originally published in the *Journal of the American Institute of Architects Proceedings*, vol. 27 (1893).

45. Ibid.

46. The significance of the title of the symposium lies in the fact that steel construction and plate glass were both unprecedented and controversial materials and both were exclusively associated with the tall building.

47. "Form follows function," summarized Sullivan's approach to architectural design as described in, Louis Sullivan, "The Tall Office Building Artistically Considered," *Lippincott's Magazine*, vol. 57 (March, 1896), pp. 403–9.

48. Dankmar Adler, "Proceedings of the Thirtieth Annual Convention of the American Institute of Architects" (1896), pp. 58–64; cited from the reprint in Lewis Mumford, *Roots of Contemporary American Architecture* (New York: Dover Publisher, 1952, 1972), p. 244.

49. Ibid., pp. 248–49.

50. Dankmar Adler received his training during four years in the Army Corps of Engineers.

51. Henry Van Brunt translated Eugène-Emmanuel Viollet-le-Duc's *Discourses on Architecture*, in two volumes (Boston 1875–1881); John Root studied and translated portions of the writings of Gottfried Semper.

52. J.W. Yost, "Proceedings of the Thirtieth Annual Convention of the American Institute of Architects" (1891), pp. 52–58; cited from the reprint in Lewis Mumford, *Roots of Contemporary American Architecture* (New York: Dover Publishers, 1952, 1972), pp. 157–58.

53. Barr Ferrée was Professor of Architecture at the University of Pennsylvania.

54. Barr Ferrée, "High Building and Its Art," *Scribner's Magazine*, vol. 15 (March, 1894), p. 316; Ferrée wrote a follow-up article ten years later wherein he stated his skepticism as to whether much progress had been made toward "the solution of the artistic expression of the high building." See Barr Ferrée, "The Art of High Building," *Architectural Record*, vol. 15 (May, 1904), pp. 445–66.

55. Sturgis, "Good Things in Modern Architecture," p. 93.

56. Ibid.

57. Ferrée, pp. 298–99.

58. Ibid., p.316.

59. Schuyler has been long admired (and rightly) by modern historians for his perceptive and sensitive analyses of these early steel-framed tall buildings. However, they have not always bothered to understand the traditional aspects of Schuyler's attitude or acknowledge statements which reflect that attitude.

60. Montgomery Schuyler, "Glimpses of Western Architecture: Chicago," *Harper's Magazine*, vol. 83 (August, 1891), pp. 395–406; (September, 1891), pp. 554–70. It is interesting to note that Schuyler's attention was first drawn to Chicago at the time when it was contending with New York City for the location of the World's Columbian Exposition.

61. Montgomery Schuyler, "Modern Architecture," in *American Architecture and other Writings*, ed. William H. Jordy and Ralph Coe (New York: Atheneum, 1961), pp. 74–75. The article was originally delivered as a Butterfield Lecture at Union College, Schenectady, New York, March 9, 1894 and then published in *Architectural Record*, vol. 4 (July-September, 1894), pp. 1–13.

62. Ibid., p. 75.

63. Montgomery Schuyler, "D.H. Burnham and Co.," excerpted in *American Architecture and Other Writings*, ed. William H. Jordy and Ralph Coe (New York: Atheneum, 1961), p. 195. The article originally appeared as a separate monograph as No. 2, Part II in the "Great American Architects Series" by *Architectural Record* (February, 1896), pp. 49–69.

64. Ibid., p. 196.

65. Ibid., p. 195.

66. Ibid., p. 196. Donald Hoffman in his excellent study of the Monadnock Block, "John Wellborn Root's Monadnock Building," *Journal of the Society of Architectural Historians*, vol. 26 (December, 1967), pp. 269–77, discusses the relationship between the client's insistence on an undecorated building and Root's unorthodox design.

67. Following the untimely death of John Root in 1891, Charles Atwood replaced him as the chief designer in the firm which now took the name of Root's surviving partner, Daniel H. Burnham. In this capacity, Atwood designed both the firm's contribution to the Chicago Fair, the highly acclaimed, Greek-inspired Art Building and the "intractable" Reliance Building. Although it has not been proven conclusively, it is now thought that Atwood substantially reworked the original 1890 design by Root for the building. Root's choice for a dark granite sheathing for the frame, still visible on the first two floors, and completed before his death, is fundamentally different from the white enameled terra-cotta sheathing of the upper floors chosen by Atwood. For a contemporary account, see: Charles E. Jenkins, "A White Enameled Building," *Architectural Record*, vol. 4 (January-March, 1895), pp. 299–306.

68. Schuyler, "D.H. Burnham and Co.," p. 199.

69. Ibid.

70. Montgomery Schuyler, "Architecture in Chicago: Adler & Sullivan," excerpted in *American Architecture and Other Writings*, ed. William H. Jordy and Ralph Coe (New York: Atheneum, 1961), p. 184. This article was originally published as a separate monograph as No. 2, Part I, in the "Great American Architect Series," by *Architectural Record* (February, 1896), pp. 3–48.

71. Charles E. Jenkins, "A White Enameled Building," *Architectural Record*, vol. 4 (January-March, 1895), pp. 299–306. The author devoted the majority of attention to the enameled terra-cotta sheathing which he prophesied would be "a conspicuous mark in the history of American Architecture" because it was weather resistant even in Chicago's severe climate, washable, and would eventually be available in lively colors. The author then described the properties (complete with illustrations of the building under construction) of the steel frame which allowed the architect to raise the remainder of the building in the space of six months above the existing two ground stories.

72. Ibid., p. 299.

73. Schuyler, "Architecture in Chicago: Adler & Sullivan," p. 184.

74. Sullivan's own lengthy discourse on this approach appeared in "The Tall Office Building Artistically Considered," *Lippincott's Magazine*, vol. 57 (March, 1896), pp. 403–9; republished in *Inland Architect & News Record*, vol. 27 (May, 1896), pp. 32–42, and *Western Architect*, vol. 31 (January, 1922), pp. 3–11.

75. Schuyler, "Architecture in Chicago: Adler & Sullivan," p. 184.

76. Ibid., p. 185.

77. Ibid., pp. 185–87.

78. Ferrée, "High Building and Its Art" (1894), p. 303; p. 200. The original order of the paragraphs has been reversed.

79. Ibid.

80. Ibid.

81. See for example: The Stock Exchange Building, Chicago, Illinois, 1893–94; project for the Trust and Savings Building, St. Louis, Missouri, 1893; Guaranty Trust (now Prudential) Building, Buffalo, New York, 1894–95; Bayard (now Condict) Building, New York, New York, 1897–98; Gage Building, Chicago, Illinois, 1898–90; Schlesinger & Mayer (now Carson, Pirie and Scott) Store, Chicago, Illinois, 1899–1904.

82. For a more detailed description of the "rise of the American skyscraper," see three

excellent articles: Carson Webster, "The Skyscraper: Logical and Historical Considerations," *Journal of the Society of Architectural Historians*, 18 (December, 1959), 126–39; Winston Weisman, "New York and the Problem of the First Skyscraper," *Journal of the Society of Architectural Historians*, 12 (March, 1953), 13–21; and Winston Weisman, "A New View of Skyscraper History," in *The Rise of an American Architecture*, ed. Edgar Kaufman, Jr. (New York: Praeger, 1970).

83. Ferrée, "The Art of the High Building," *Architectural Record*, vol. 15 (May, 1904), p. 462.

84. Ibid., p.463.

85. Ibid.

86. Ibi., p. 463.

87. Now the Carson, Pirie and Scott Store, Chicago, Ill.

88. H.W. Desmond, "The Schlesinger & Mayer Building; What Mr. Louis Sullivan Stands For," *Architectural Record*, vol. 16 (July, 1904), p. 66.

89. Ibid.

90. Sturgis, "Good Things in Modern Architecture," p. 105.

91. Ibid., p. 101.

92. Ibid.

93. Lyndon P. Smith, "The Schlesinger & Mayer Building; An Attempt to Give Functional Expression to the Architecture of A Department Store," *Architectural Record*, vol. 16 (July, 1904), p. 53.

94. Van Brunt, "The Growth of a Characteristic Architectural Style in the United States," p. 325.

95. Desmond, "The Schlesinger & Mayer Building," p. 66.

96. Sturgis, "Good Things in Modern Architecture," p. 92.

97. Ibid.

98. Henry W. Desmond and Herbert Croly, "The Work of Messrs. McKim, Mead and White," *Architectural Record*, vol. 20 (September, 1906), p. 182.

99. Ibid.

100. Ibid., p. 183.

101. Van Brunt, "The Growth of a Charactersitic Architectural Style in the United States," p. 325. The original order of the two paragraphs has been reversed.

Chapter 4

1. A.D.F. Hamlin, "Style in Architecture," from "The Modern Architectural Problem Discussed from the Professional Point of View, *The Craftsman*, vol. 8 (June, 1905), p. 331.

2. Ibid.

3. Ernest Flagg, "American Architecture as Opposed to Architecture in America," *Architectural Record*, vol. 10 (October, 1900), pp. 178–80.

4. Ralph Adams Cram, "Style in American Architecture," *Yale Review*, vol. 2 (July, 1913), p. 647; the article was originally presented as an address before the Contemporary Club of Philadelphia; the same article was later reprinted in the *Architectural Record*, vol. 34 (September, 1913), pp. 233–39.

5. As Cram described the new situation: "From a purely professional standpoint the most encouraging thing is the breadth of culture, the philosophical insight into the essence of things, the liberality of judgment that mark so many of the architectural profession to-day" ("Style in American Architecture," p. 647).

6. Ibid.

7. Ibid., p. 648.

8. Ibid., p. 649.

9. A.D.F. Hamlin, "Twenty-five Years of American Architecture," p. 10. However, it would be a mistake to assume that when Hamlin described the "sky-scraper" as revolutionary, he meant anything more definite than a reference to its unprecedented form and structure. As he made clear in a later statement, he never meant a revolutionary "style."

10. See discussion above, chapter 2.

11. The Romanesque was especially popular in Chicago and the midwest following the example of H.H. Richardson's Marshall Field Store, Chicago, 1885–87. See for example, the prestigious commissions of John Root; The Insurance Exchange, Chicago, 1884–85 (demolished 1912); "The Rookery," Chicago, 1885–86; The Woman's Temple, Chicago, 1891–92; also see Adler and Sullivan's Auditorium Building, Chicago, 1887–89; the Schiller Building, Chicago, 1891–92; Stock Exchange, Chicago, 1893–94. For an interesting account of these designs by someone familiar, as a young man, with their inception, see Thomas E. Tallmadge, *Architecture in Old Chicago*, Chicago, 1941.

12. In New York City, particularly, architects experienced with Renaissance and related designs, produced "palazzo" skyscrapers, such as the American Surety Building, completed in 1895 by Bruce Price; the Banker's Trust Building by Trowbridge and Livingston; the Metropolitan Life Insurance Tower, by N. LeBrun and Sons; the Municipal Building by McKim, Mead and White, 1914; the Singer Tower, 1908 by Ernest Flagg.

13. Lamb, "Modern Use of the Gothic," p. 150.

14. Ibid.

15. Henry W. Desmond and Herbert Croly, "The Work of Messrs. McKim, Mead and White," *Architectural Record*, vol. 20 (September, 1906), pp. 240–41.

16. Lamb, "Modern Use of the Gothic," pp. 165 and 169.

17. Ibid., pp. 169–70. A.D.F. Hamlin, who is quoted by Lamb, noted the empirical quality of the Gothic which was also believed to characterize the skyscraper: "Gothic architecture was constantly changing, attacking new problems or devising new solutions to old ones. In this character of constant flux and development, it contrasts strongly with the classic styles, in which the scheme and the principle were nearly fixed and remain substantially unchanged for centuries" (Lamb, p. 169).

18. Ibid., p. 170.

19. Bertram Goodhue, "The Romanticist Point of View," from "The Modern Architectural Problem Discussed from the Professional Point of View," *The Craftsman*, vol. 8 (June, 1905), p. 332.

20. Hamlin, "Style in Architecture," p. 329.

21. Ibid., pp. 326 and 329.

22. Ibid., p. 330.

23. Ibid.

24. Ibid. This analogy suggests a number of interesting contradictions, although it remained a favorite of this generation. (See Barr Ferrée, above p. 52.) While the human body analogy indicates skin as the outer covering and this is indeed intregal with the form and function of the body, the architectural "covering" to which it is compared is not equivalent in function and certainly not in form. The more appropriate comparison would have been to another already suggested, that is, the clothing or costuming draped over the human body. Furthermore, one cannot help but wonder at the post-Victorian daring which permitted Hamlin to assume for all his readers that the naked body was "exquisitely beautiful."

25. Ibid.

26. Ibid., p. 331.

27. Ibid.

28. Cass Gilbert, quoted in Paul Goldberger, "A Life Renewed for 'Cathedral of Commerce', "*The New York Times* (Thursday, November 5, 1981), p. B2.

29. Montgomery Schuyler, "The Towers of Manhattan and Notes on the Woolworth Building," *Architectural Record*, vol. 33 (February, 1913), p. 106. Schuyler also perceived this expressive quality in Flagg's treatment of the Singer Tower based on the French Beaux-Arts style.

30. Ibid.

31. Ibid.

32. Ibid. Italics have been added.

33. Ibid.

34. See for example, C. Howard Walker, "Modern Architecture in Review: Style and Adaptation," *The Craftsman*, vol. 9 (October, 1905), pp. 36–40.

35. It should be noted that Louis Sullivan sheathed the Wainwright with a combination of granite and terra-cotta; the Prudential Building is clad exclusively in terra-cotta, moulded according to Sullivan's original decorative designs, for both practical and expressive reasons.

36. Schuyler, "The Towers of Manhattan," p. 106.

37. Ibid.

38. Walker, p. 36.

39. Schuyler, "The Towers of Manhattan," p. 111.

40. Ibid.

41. Ibid.

42. Ibid.

43. "Program of the Competition," *The Tribune Competition* (Chicago: The Tribune Company, 1923), p. 17.

44. Third prize was awarded to the design submitted by the Chicago firm of Holabird and Roche. They were the surviving firm from among the original young designers who have since come to be known as "the Chicago School," and even at the time were well known for their Chicago commercial style structures, e.g. the Tacoma Builidng, 1887-89; the Marquette Building, 1893-94; the Old Colony Building, 1893-94; the south addition to the Monadnock, 1893; the Gage Group, 1898-99; McClurg Building, 1899-1900.

45. Of these 42 Gothic designs, 32 were by American architects, 10 by Europeans.

46. John Mead Howells and Raymond Hood, "First Prize Winner," *The Tribune Competition* (Chicago: The Tribune Company, 1923), p. 106.

47. Ibid.

48. "Program of the Competition," *The Tribune Competition*, p. 20. The four businessmen were members of the Tribune Building Corporation. The single architect was a member of the Illinois chapter of the American Institute of Architects.

49. "Report of the Jury of Award," *The Tribune Competition* (Chicago: The Tribune Competition Company, 1923), p. 37.

50. Ibid., p. 144.

51. Well known today is the ironic fact taht among the Europeans who submitted designs were Otto Hoffmann of Austria, Adolph Loos of France, Walter Gropius, Adolph Meyer and Bruno Taut of Germany, all of whom are now recognized as pioneers of the modern movement in Europe. The fact that the Tribune jury did not admire their designs does not, however, bring into question the outstanding quality of Saarinen's design.

52. "Report of the Jury of Award," pp. 43-44. Italics added.

53. Kent, "The Chicago Tribune Competition," p. 379.

54. Edgell, *The American Architecture of To-day*, p. 73-75.

55. Louis Sullivan, "The Chicago Tribune Competition," *Architectural Record*, vol. 53 (February, 1923), p. 153.

56. Ibid., p. 156.

57. Ibid.

58. Not only is this building included in most subsequent contemporary reviews of skyscraper designs, it also inspired the artist Georgia O'Keeffe during her sojourn in New York City during the twenties.

59. See Harvey Wiley Corbett, "The American Radiator Building, New York City," *Architectural Record*, vol. 55 (May, 1924), pp. 476-77. Interestingly, Corbett was to become the chairman of the Architectural Committee for the 1933 "Century of Progress Exposition" in Chicago.

60. The set-back arrangement of diminishing buttress-like masses is usually considered as a response to the 1916 New York City zoning restrictions. See discussion below, chapter 5.

61. Corbett, "The American Radiator Building," p. 477.

62. A.D.F. Hamlin, "Twenty-five Years of American Architecture," p. 3. The second potent

force he considered to be, "the influence of several great exhibitions, especially of that at Chicago in 1893."

63. Ibid.

64. See for example: A.C. David, "The New Architecture; The First American Type of Real Value," *Architectural Record*, vol. 28 (December, 1910), pp. 389–433; Russell Sturgis, "The Larkin Building in Buffalo," *Architectural Record*, vol. 23 (April, 1908), pp. 311–21.

65. David, "The New Architecture, p. 394.

66. Sturgis, "Good Things in Modern Architecture," p. 93.

67. Ibid., pp. 93–94. Sturgis illustrated his plea for "plain" building with examples from both traditional and modern types. He analyzed the classically based Ecole de Droit in Paris as an example of "radical and rational bulding" (p. 97). He described the church of Castellane in (Basses Alpes) France, which he called, "medieval in general character and that from obvious reasons" (p. 97). The American examples he admired were a Shingle Style house in Orange, New Jersey, the "collegiate" Gothic design for the Columbia College Library in New York and the metal supported Bayard Building, also in New York. All of these he admired for their "constructional sincerity and . . . rational design" (p. 105). It is interesting to note that Sturgis's choice of examples reflects not only a still basically precedent-based approach to design, but also a sense of eclectic "appropriateness," e.g., the classical is chosen for the law school, the medieval for a church, and finally a "rational" metal frame for the tall building, etc.

68. Cram, "Style in American Architecture," p. 236.

69. Ibid. However, he confused his sense of the steel frame as part of radical style with his reference to the unwise use of the steel frame, "to reproduce the Baths of Caracalla . . . or build a second Chartres Cathedral."

70. Ibid.

71. Ibid.

72. C. Matlack Price, "The Trend of Architectural Thought in America," *The Century Magazine*, vol. 102 (September, 1921), p. 718.

73. Ibid.

74. Ibid.

75. Ibid.

76. Ibid.

77. Ibid.

78. See for example: "Kindergarten Chats," originally published in *Interstate Architect & Bulletin* (52 issues from February 16, 1901 to February 8, 1902); "An Unaffected School of Modern Architecture: Will It Come?" *Artist*, vol. 24 (January, 1899), pp. 33–34; "Is Our Art a Betrayal Rather Than an Expression of American Life?" *The Craftsman*, vol. 15 (January, 1909), pp. 402–4.

79. Louis Sullivan, "Reply to Mr. Frederick Stymetz Lamb on 'Modern Use of the Gothic; the Possibility of New Architectural Style,'" *The Craftsman*, vol. 8 (June, 1905), p. 336.

80. Ibid., p. 337.

81. Within a few years his one-time protegées and self-appointed disciples, Claude Bragdon and Frank Lloyd Wright, would take up the same theme. Indeed, by 1922, Sullivan's own credibility had revived — ironically only two years before his death in 1924. On the other hand, his death at this crucial point also served to revive interest in Sullivan and his idea.

82. Walker, p. 39.

Chapter 5

1. Irving Howe, "Introduction," *The Idea of the Modern* (Horizon Press: New York, 1967), pp. 12–13.

2. Edgell, *The American Architecture of To-day*, p. 83.

3. Raymond Hood, "The Spirit of Modern Art," *Architectural Forum*, vol. 51 (November, 1939), p. 445.

4. Randolf Williams Sexton, *The Logic of Modern Architecture* (Architectural Book Publishing Co.: New York, 1929), p. 1.

5. Le Corbusier's highly influential treatise was first published in an English edition in 1927 by the Architectural Press, London.

6. George Edgell, born in 1887, received his Ph.D. from Harvard University and was the Dean of the Faculty of Architecture and Chairman of the Council of the School of Architecture at Harvard University between 1922 and 1935. Sidney Fiske Kimball, born in 1888, received an M. Arch. from Harvard University and a Ph.D. from the University of Michigan; he was Professor of Art and Architecture at the University of Virginia between 1919 and 1923, Chairman of the Department of Fine Art at New York University between 1923 and 1925 and Director of the Philadelphia Museum of Fine Arts after 1925.

7. Edgell, *The American Architecture of To-day*, p. 3. The irony of Edgell's definition of modern is quite forceful today, considering the recent announcements of the "death" of modern architecture and the passage into the post-modern era.

8. Fiske Kimball, "Louis Sullivan — an Old Master," *Architectural Record*, 57 (April, 1925), 303.

9. Edgell, *The American Architecture of To-day*, p. 83.

10. Ibid. Italics added.

11. Fiske Kimball, "What is Modern Architecture?" *The Nation*, 119 (July, 1924), p. 128.

12. Fiske Kimball, "The Classic in the Skyscraper," *Architectural Record*, 57 (February, 1925), p. 189.

13. Edgell, *The American Architecture of To-day*, p. 75. Edgell referred to the Savoy-Plaza Hotel by McKim, Mead and White.

14. Ibid.

15. Ibid., pp. 75–76.

16. Kimball, "What is Modern Architecture?" p. 129. See also: Kimball, "Louis Sullivan — An Old Master," p. 304.

17. Kimball, "What is Modern Architecture?" p. 128. Kimball may have been reacting to criticisms such as those leveled by Lewis Mumford.

18. Ibid. Kimball also discusses this in "Louis Sullivan — An Old Master," and develops it further in his book-length study, *American Architecture* (New York: The Bobbs-Merrill Company, 1928).

19. Kimball, *American Architecture*, chapter XII, "What is Modern Architecture? The Poles of Modernism: Function and Form," pp. 147–68.

20. Kimball, "What is Modern Architecture?" p. 129; also "Louis Sullivan — An Old Master," p. 303.

21. Kimball, "Louis Sullivan — An Old Master," p. 303.

22. Ibid.; also "What is Modern Architecture?" p. 129 and *American Architecture*, p. 304.

23. Kimball, "Louis Sullivan — An Old Master," p. 340.

24. Ibid. Kimball called Louis Sullivan the Monet of architecture, whereas he called Joseph Wells, a designer for McKim, Mead and White, the Cézanne of the art.

25. Ibid.

26. Louis H. Sullivan, *The Autobiography of An Idea* (New York: Dover Publications, 1956 reprint), pp. 324–35; originally published in 1924 by the American Institute of Architects.

27. For a further discussion of the development of the Sullivan legend see: Deborah F. Pokinski, "The Legend of the Chicago School: A Study in the Historiography of Modern American Architecture" (unpublished M.A. thesis, Cornell University, 1973).

28. Thomas E. Tallmadge, *The Story of Architecture in America* (New York: W.W. Norton and Co., Inc., 1927). See Chapter IX, "Louis Sullivan and the Lost Cause."

29. As Tallmadge wrote in 1936: "A tremendous change . . . has occurred in the last five years in regard to Sullivan's proper position in the history of architecture. More and more he is regarded as the *true father* of the vast architectural phenomenon known as the 'New Architecture' or better, I think, as the 'International Style'" (p. 215).

30. Edgell, *The American Architecture of To-day*, pp. 76–77. Wrote Edgell: "It is the modernistic movement which has made great strides, especially in the West. Its roots are found in the work of Adler and Sullivan, in Chicago."

31. Kimball, *American Architecture*, p. 203.

32. Ibid., p. 209.

33. Ibid., p. 210.

34. Ibid., pp. 204–25.

35. Talbot Faulkner Hamlin, *The American Spirit in Architecture* (New Haven: Yale University Press, 1926), p. 325.

36. Kimball, *American Architecture*, p. 211.

37. Ibid.

38. According to an explanation by the Executive Secretary, Zoning Committee, New York: "The basis for the regulations in the different zones is a multiple of the street widths. In the least restricted section, [this is where skyscrapers would predominate] buildings may

be built at the street line to a height of two and a half times the width of the widest abutting street. Beyond that point, they are permitted to go up to any height . . . so long as their facades are set back at the rate of one foot horizontally for every five feet of building height" (p. 129). Herbert S. Swan, "Making the New York Zoning Ordinance Better," *Architectural Forum*, 35 (October, 1921), pp. 125–30.

39. Both George Edgell and Talbot Hamlin used reproductions of Ferriss's renderings to illustrate their discussions of "set-back" skyscrapers. See: George Edgell, *The American Architecture of To-Day* and Talbot F. Hamlin, *The American Spirit in Architecture*.

40. Edgell, p. 356.

41. For further discussion of Hugh Ferriss and his influence see: Jean Ferriss Leich, *Architectural Visions: The Drawings of Hugh Ferriss* (New York: Whitney Library of Design, 1980).

42. Part of the zoning law allowed for a tower of unrestricted height of no more than 25 percent of the lot area. See Harvey Corbett, "The Birth and Development of the Tall Building," *American Architect*, vol. 129 (January, 1926), pp. 37–40.

43. Hamlin, *The American Spirit in Architecture*, p. 327.

44. Edgell, *American Architecture of To-Day*, p. 356. Italics added.

45. Jean Ferriss Leich, *Architectural Visions: The Drawings of Hugh Ferriss*, with an Essay by Paul Goldberger and a Forward by Adolph Plaszek (New York: Whitney Library of Design, 1980), p. 17.

46. Irving K. Pond, "Zoning and the Architecture of High Buildings," *Architectural Forum*, vol. 35 (October, 1921), p. 133.

47. Evidence of their significance can be seen in the most recent tall building designs, sometimes called "shaped skyscrapers," but in reality a revival of the set-back schemes.

48. Mumford later wrote that he approached his subject in *Sticks and Stones* with the temerity of "a young man, with no reputation to risk" (Mumford, *Sticks and Stones*, "Preface" to the 1954 edition [New York: Dover Publications, Inc., 1954]. The book was originally published in 1924 by Boni and Liveright, Inc.

49. Lewis Mumford, "Architecture and History," *Journal of the American Institute of Architects*, vol. 12 (April, 1924), p. 192.

50. Mumford, *Sticks and Stones*, p. 129.

51. Ibid., p. 149.

52. Ibid., title of chapter six.

53. Ibid., p. 136.

54. Ibid., p. 129.

55. Ibid., p. 140.

56. Ibid., title of chapter seven.

57. Ibid., p. 169.

58. Lewis Mumford, "American Architecture To-day" *Architecture*, vol. 57 (April, 1928), p. 181.

59. Ibid., pp. 183–84.

60. Ibid., p. 184. Italics added.

61. Ibid.

62. Ibid., p. 182.

63. Ibid., p. 186.

64. Alfred C. Bossom, "Fifty Years' Progress Toward an American Style in Architecture," *American Architect*, vol. 129 (January, 1926), p. 47.

65. Ibid., p. 49.

66. Royal Cortissoz, "Fifty Years of American Architecture," *American Architect*, vol. 129 (January, 1926), p. 3.

67. Ibid.

68. Thomas E. Tallmadge, "Types, Past and Present," *American Architecture*, vol. 129 (January, 1926), p. 13. Tallmadge praised only the Woolworth Building, the Bush Terminal Building and the American Radiator Company Building. He considered Saarinen's Tribune Competition design to be "the best solution so far" (p. 13).

69. Ibid., p. 14.

70. Ibid.

71. Ibid.

72. Hood, "The Spirit of Modern Art," p. 445.

73. Ibid. Italics added.

74. Corbett, "The Meaning of Modernism," *The Architect*, vol. 12 (June, 1929), p. 26.

75. Ibid.

76. Ibid., p. 272.

77. Louis Leonard, "What is Modernism?" *The American Architect*, vol. 136 (November, 1929), p. 22.

78. Ibid. Frank Lloyd Wright was himself skeptical of "this intensive rush for a place in the 'new school'." He called it superficial and exploitive. See: Frank Lloyd Wright, "In the Cause of Architecture," *Architectural Record*, vol. 64 (1928), pp. 405–13.

79. Ibid., p. 24. Italics added.

80. Both Leonard and Corbett were concerned with form and with how the new architecture looked and would look. But they differed in their conception of how the formal expression would be achieved. Leonard conceived of an organic beauty suggested from within, or from the new forms determined by the new structural materials. Corbett, on the other hand, saw beauty reflected from the abstract manipulation of the newly generated forms and surfaces. Essentially, however, theirs was the age old difference between the organic and the idealistic approaches to design which had been manifest for centuries not to mention throughout the past decades in American architecture.

81. Leonard, p. 24. Italics added.

82. One writer who made this clear was Randolf Williams Sexton in *The Logic of Modern Architecture* (New York: Architectural Book Publishing Co., 1929). It was also made clear by architect Paul Cret in "Ten Years of Modernism," *Architectural Forum* 57 (August, 1933) pp. 91–4.

83. Hood, "The Spirit of Modern Art," p. 445.

84. Ibid., p. 448. Italics added.

85. Ibid.

86. Ibid.

87. Ibid.

88. William Jordy describes the Daily News Building as "gothicized modern" in comments included in *The Impact of European Modernism in the Mid-Twentieth Century*, vol. IV of *American Buildings and Their Architects* (New York: 1972), p. 59.

89. Hood and his partners, Godley and Fouilhoux, were one of the three firms of associated architects who developed the plans for the entire Rockefeller Center project.

90. Philip Johnson was Director of the Museum's Department of Architecture and Design from 1930 to 1936 and again from 1946 to 1954. He was also Director of the 1932 Exhibition of International Architecture.

91. Alfred H. Barr, Jr., Foreword to the catalogue of the exhibition, *Modern Architecture: International Exhibition* (New York: Museum of Modern Art, 1932; reprint ed., Arno Press, 1969), p. 13.

92. Ibid.

93. Ibid., p. 15.

94. Ibid.

95. In fact, Hood was the second exception. Frank Lloyd Wright was also included, although, explained Barr, his work was not "intimately related to the Style," but, "his early work was one of the Style's most important sources" (p. 15).

96. Barr, pp. 15-16.

97. Ibid., p. 16.

98. Henry-Russell Hitchcock, "Howe and Lescaze," from *Modern Architecture: International Exhibition* (New York: Museum of Modern Art, 1932; reprint edition, Arno Press, 1969), p. 145.

99. Ibid.

100. Ibid. Italics added.

101. Ibid., p. 144.

102. Ibid.

103. See, for example, the discussions of the PSFS Building in: William Jordy, *American Buildings and Their Architects*, vol. IV. *The Impact of European Modernism in the Twentieth Century*, and Margaretta Jean Darnall, "From the Chicago Fair to Walter Gropius: Changing Ideals in American Architecture" (Unpublished Ph.D. Dissertation, Cornell University, 1975).

104. Sheldon Cheney, *The New World Architecture* (New York: 1930; reprinted ed., AMS Press, Inc., 1969), pp. 13-14.

105. Ibid., p. 18. Italics added.

106. Ibid., pp. 54-55.

107. Ibid., p. 65 Italics added.

108. Ibid., p. 228.

109. Ibid., pp. 122–23.

110. Hitchcock and Johnson, *The International Style*, p. 24.

111. The term "Chicago School" was not commonly used to designate the group of tall, commercial, steel-framed structures of late nineteenth-century Chicago until after the 1933 Museum of Modern Art exhibition treating these structures, entitled *Early Modern Architecture: Chicago: 1870–1910.*

112. Lewis Mumford, *The Brown Decades* (1931; revised ed., Dover Publications, Inc., 1955), pp. 113–14.

113. The commercial works of Louis Sullivan, John Root and their contemporaries soon became the object of reinterpretation by the proponents of modern architecture, both American and European; unfortunately, this reinterpretation was based on the largely European premise that modern architecture was inevitable, polemical and preferable, which gave rise to a "legend" rather than to a proper history of the so-called Chicago School. In the legend it appears that the proto-modern school of Chicago tall buildings was wantonly choked off by reactionary forces. For a full discussion of the development of the "legend" of the Chicago School see: Deborah F. Pokinski, "The Legend of the Chicago School of Architecture: A Study in the Historiography of Modern American Architecture" (unpublished M.A. thesis, Cornell University, 1973).

114. Hitchcock and Johnson, *The International Style*, p. 74.

Chapter 6

1. Mumford, "Two Chicago Fairs," *The New Republic*, vol. 65 (January 21, 1931), p. 271.

2. Ibid.

3. One of the most spectacular and symbolic links with the 1893 Fair had to do with the official opening of the 1933 Fair. At the opening, a huge searchlight, trained on the tower of the Hall of Science, was illuminated by an electric current which had been ultimately generated by a ray of light from the orange star Arcturus, a ray of light which had left the star forty years before in 1893. See: "Starring a Star at Chicago Cubist Fair," *Literary Digest*, vol. 113 (May 7, 1932), p. 34; also, *Newsweek*, vol. 1 (May 27, 1933), p. 8.

4. Mumford, "Two Chicago Fairs," p. 271. Italics added.

5. "Branding the Buildings at the Chicago Fair," *The Literary Digest*, vol. 116 (August 12, 1933), p. 14.

6. Ibid.

7. A.D. Albert and F. Crissey, "Why the Century of Progress Architecture?" *The Saturday Evening Post*, vol. 205 (June 19, 1933), p. 17.

8. William G. Shepherd, "Fair for Tomorrow," *Collier's Magazine*, vol. 90 (September 17, 1932), p. 10.

9. The city of Chicago intended the Fair to celebrate their centennial and the extraordinary progress their city had made since its founding, and which they attributed primarily to

modern scientific and technological advances. The Hall of Science, designed by Paul Cret, was considered to be the focal point of the Fair. As the Official Guide Book of the Fair noted: "As two partner's might clasp hands, Chicago's growth and the growth of science and industry have been united during this most amazing century" (p. 11).

10. The German Pavilion, built of steel, glass, marble and travertine, was Mies van der Rohe's early masterpiece of avant-garde architecture; it was widely known and admired through reproductions.

11. Harvey W. Corbett, "How A Century of Progress Exposition Was Created," *Architect and Engineer*, vol. 113 (June, 1933), p. 18.

12. The members of the Commission included, Raymond M. Hood, Harvey W. Corbett and Ralph T. Walker of New York, Paul Philippe Cret of Philadelphia, Arthur Brown, Jr., of San Francisco, Edward H. Bennett, John A. Holabird and Hubert Burnham of Chicago. For a more detailed discussion, see: Forest F. Lisle, "The Century of Progress Exposition: 1933 Chicago's Architecture of American Democracy (unpublished M.A. Thesis, Cornell University, 1970).

13. Paul Cret was professor of architecture at the University of Pennsylvania.

14. Charles S. Peterson, "The 1933 World's Fair," *Pencil Points*, vol. 10 (April, 1929), p. 124. Italics added.

15. For instance, Louis Skidmore (later of the firm of Skidmore, Owings and Merrill), Chief of Design, wrote a whole article devoted to the structural innovations necessitated by the transitory nature of fair architecture and by the economic strictures after 1929 on the design of Paul Cret's Hall of Science. He noted, for example, the use of concrete for the foundation and wall beams, structural steel girders and columns, laminated plywood flooring with ground cork tile covering, laminated wall board for the walls, and elaborate indirect interior and exterior lighting. See: Louis Skidmore, "The Hall of Science, a Century of Progress Exposition; Details of Structure of Equipment," *Architectural Forum*, vol. 57 (October, 1932), pp. 361–66.

16. Allen D. Albert, "Chicago Invites the World," *Review of Reviews and the World's Work*, vol. 87 (May, 1933), p. 18.

17. The Fair itself was an economic success, so much so that it was reopened the following year.

18. Bert M. Thorud, "Engineering Research and Building Construction," *Architectural Forum*, vol. 59 (July, 1933), pp. 65–66.

19. The sources for these decorative schemes were varied and included the 1925 Paris Exposition of Decorative Arts, the example of the set-back skyscrapers, the concept of machine-art, the influence of renewed interest in Pre-Columbian Art, and even the compositions and detailing of Frank Lloyd Wright's work. For a more detailed discussion, see: Forest Lisle, "The Century of Progress Exposition."

20. Paul Phillipe Cret, "The Hall of Science, A Century of Progress Exposition," *Architectural Forum*, vol. 57 (October, 1932), pp. 293–396.

21. Mumford, "Two Chicago Fairs," p. 271.

22. Hitchcock and Johnson, *The International Style*, p. 37.

23. Ibid.

24. The designers of these pavilions were: Dairy Pavilion, Bennett and Brown; the General

Exhibits Building, Harvey Corbett; Chrysler Motors Building, Holabird and Root; and Ford Motors Pavilion, Albet Kahn.

Chapter 7

1. Walter Gropius (1883–1969) who had been the first director of the Bauhaus, from 1919 to 1928, and the designer of its influential physical plant, arrived in this country from Germany via England in 1937. He organized The Architects Collaborative, through which he practiced, in 1945. He was also a professor of architecture in the Architectural Design School at Harvard University. His former colleague at the Bauhaus, Las László Moholy-Nagy (1895–1946) also emigrated to this cuntry in 1937 and established himself as the Director of the Chicago Institute of Design. Ludwig Mies van der Rohe (1883–1969), who succeeded Gropius as the director of the Bauhaus from 1930 to 1933, arrived in the U.S. from Germany in 1937. He subsequently became director of the Architecture School at the Illinois Institute of Technology.

2. Raymond Hood died prematurely in 1934. Paul Cret died in 1945. Corbett lived until 1954, but his influence was sadly diminished.

3. Paul P. Cret, "Ten Years of Modernism," *The Architectural Forum*, vol. 59 (August, 1933), p. 94.

4. Rowe, "Roots of American Architecture: An Answer to Mumford's Analysis," *Architectural Review*, vol. 116 (August, 1954), p. 76.

Bibliography

Books

Behrendt, Walter Curt. *Modern Building*. New York: Harcourt, Brace, 1927.

Bragdon, Claude. *Architecture and Democrary*. New York: Alfred A. Knopf, 1918.

Cheney, Sheldon. *The New World Architecture*. New York: 1930. Reprint. New York: AMS Press, Inc., 1969.

Darnall, Margaretta Jean. "From the Chicago Fair to Walter Gropius: Changing Attitudes in American Architecture." Unpublished Dissertation, Cornell University, 1975.

Edgell, George Harold. *The American Architecture of To-day*. New York: Charles Scribner's Sons, 1928.

Five Architects: Eisenman, Graves, Gwathmey, Hejduk, Meier. With an introduction by Colin Rowe. New York: Wittenborn, Press, 1972.

Giedion, Sigfried. *Space, Time and Architecture*. Cambridge, Mass.: Harvard University Press, 1941; 5th edition, 1967.

Gropius, Walter. *The New Architecture and the Bauhaus*. New York: Museum of Modern Art, 1936.

Hamlin, Talbot Faulkner. *The American Spirit in Architecture*. New Haven: Yale University Press, 1926.

Hitchcock, Henry-Russell, Jr. and Philip Johnson. *The International Style*. New York: W.W. Norton & Company, Inc., 1932. Reprint.1966.

Hitchcock, Henry-Russell, Jr. *Modern Architecture: Romanticism and Reintegration*. 1929. Reprint. New York: Hacker Art Books, 1970.

Hoffman, Donald. *The Architecture of John Wellborn Root*. Baltimore, Md.: Johns Hopkins University Press, 1973.

Jordy, William H. *American Buildings and Their Architects*. Vol. IV, *The Impact of European Modernism in the Mid-Twentieth Century*. New York: Anchor Press, 1976.

_____.*American Buildings and Their Architects*. Vol. III, *Progressive and Academic Ideals at the Turn of the Twentieth Century*. New York: Doubleday & Company, 1972.

Kaufmann, Edgar, ed. *The Rise of an American Architecture*. New York: Praeger Publishers, 1970.

Kidney, Walter C. *The Architecture of Choice: Eclecticism in America 1880–1930*. New York: George Braziller, 1974.

Kimball, Fiske. *American Architecture*. New York: The Bobbs-Merrill Company, 1928.

Le Corbusier. *Towards a New Architecture*. Suffolk, England: Richard Clay & Sons, Limited, 1931.

Leich, Jean Ferriss. *Architectural Visions: The Drawings of Hugh Ferriss*. With an essay by Paul Goldberger. Forward by Adolf Placzek. New York: Watson-Guptill Publications, 1980.

Lisle, Forrest F. "The Century of Progress Exposition: 1933 Chicago's Architecture of American Democracy." Unpublished M.A. Thesis, Cornell University, 1970.

Mumford, Lewis. *The Brown Decades: A Study of the Arts in America, 1865-1895*. New York: Harcourt, Brace and Co., 1931.

Mumford, Lewis, ed. *Roots of Contemporary American Architecture*. New York: Reinhold, 1952.

Mumford, Lewis. *Sticks and Stones: A Study of American Architecture and Civilization*. New York: Boni and Liveright, Inc., 1924.

Museum of Modern Art. *Modern Architecture: International Exhibition*. New York: Museum of Modern Art, 1932. Reprint. New York: Arno Press, 1969.

Pevsner, Nikolaus, *Pioneers of Modern Design*. Harmondsworth, England: Penguin Books Limited, 1960.

Robinson, Cervin, and Rosemarie Haag Bletter. *Skyscraper Style: Art Deco New York*. Oxford University Press, 1975.

Root, John Wellborn. Donald Hoffmann, ed. *The Meanings of Architecture: Buildings and Writings*. New York: Horizon Press, 1967.

Schuyler, Montgomery. *American Architecture & Other Writings*. Edited by William Jordy and Ralph Coe. New York: Atheneum, 1964.

Sexton, Randolf Williams. *The Logic of Modern Architecture*. New York: Architectural Book Publishing Co., 1929.

Starrett, William Aiken. *Skyscrapers and the Men Who Build Them*. New York: C. Scribner's & Sons, 1928.

Sullivan, Louis. *The Autobiography of an Idea*. New York: American Institute of Architects, 1924. Reprint. New York: Dover Publications, Inc. 1956.

Tallmadge, Thomas E. *The Story of Architecture in America*. New York: W.W. Norton & Company, Inc., 1927; 1936.

Tomsich, John A. *A Genteel Endeavor: American Culture and Politics in the Gilded Age*. Stanford, CA.: Stanford University Press, 1971.

Van Brunt, Henry. *Architecture and Society: Selected Essays by Henry Van Brunt*. Edited with an Introduction by William A. Coles. Cambridge, Mass.: Belknap Press of Harvard University, 1969.

Vanderbilt, Kermit. *Charles Eliot Norton: Apostle of Culture in Democracy*. Cambridge, Mass., 1959.

Watkin, David. *Morality and Architecture*. Oxford: Clarendon Press, 1977.

Articles

Albert, Allen D. "Chicago Invites the World." *Review of Reviews and the World's Work*, vol. 87 (May, 1933), pp. 16-18.

Albert, Allen D., and F. Crissey. "Why the Century of Progress Architecture?" *The Saturday Evening Post*, vol. 205 (June 10, 1933), pp. 16-17; 60-64.

"Architecture at the World's Fair." *The Review of Reviews*, vol. 8 (September, 1893), pp. 318-319.

Barney, J. Stewart. "Our National Style of Architecture will be Established on Truth Not Tradition." *Architectural Record*, vol. 24 (July-December, 1908), pp. 381-386.

Bossom, Alfred C. "Fifty Years' Progress Toward an American Style in Architecture." *American Architect*, vol. 129 (January, 1926), pp. 43-49.

"Branding the Buildings at the Chicago Fair." *Literary Digest*, vol. 116 (August 12, 1933), p. 14.

Bragdon, Claude. "Architecture in the United States." *Architectural Record*, vol. 25 (June, 1909), pp. 426-433; vol. 26 (July, 1909) pp. 38-45; vol. 26 (August, 1909), pp. 84-96.

Butler, Howard Crosby. "An American Style of Architecture." *The Critic*, vol. 20 (September 30, 1893), p. 203.

Corbett, Harvey Wiley. "The American Radiator Building, New York City." *Architectural Record*, vol. 55 (May, 1924), 476–477.

_____. "The Birth and Development of the Tall Building." *American Architect*, vol. 129 (January, 1926), pp. 37–40.

_____. "How a Century of Progress Exposition was Created." *Architect and Engineer*, vol. 113 (June, 1933), pp. 25–29.

_____. "The Meaning of Modernism." *The Architect*, vol. 12 (June, 1929), pp. 268–272.

_____. "The Significance of the Exposition." *The Architectural Forum*, vol. 59 (July, 1933), p. 22.

Cortissoz, Royal. "Fifty Years of American Architecture." *American Architect*, vol. 129 (January, 1926), pp. 1–5.

Cram, Ralph Adams. "Style in American Architecture." *Yale Review*, vol. 2 (July, 1913), pp. 639–652,

Cret, Paul Philippe. "The Hall of Science, A Century of Progress Exposition." *Architectural Forum*, vol. 57 (October, 1932), pp. 293–296.

_____. "Ten Years of Modernism." *The Architectural Forum*, vol. 59 (August, 1933), pp. 91–94.

_____. "Truth and Tradition." *Architectural Record*, vol. 25 (February, 1909), pp. 106–108.

David, A.C. "The New Architecture." *Architectural Record*, vol. 28 (December, 1910), pp. 389–403.

Desmond, Henry W. "The Schlesinger & Mayer Building: Another View." *Architectural Record*, vol. 16 (July, 1904), pp. 61–67.

Desmond, Henry W., and Herbert Croly. "The Work of Messrs. McKim, Mead & White." *Architectural Record*, vol. 20 (September, 1906), pp. 153–246.

Embury, Aymar II. "New York's Architecture: The Effect of the Zoning Law on High Buildings." *Architectural Forum*, vol. 35 (October, 1921), pp. 119–124.

Ferrée, Barr. "The American Conception of Architecture." *New Englander and Yale Review*, vol. 54 (May, 1891), pp. 385–394.

_____. "Architecture as Affected by the Progress of Civilization." *New Englander and Yale Review*, vol. 54 (February, 1891), pp. 116–131.

_____. "The Art of the High Building." *Architectural Record*, vol. 15 (March, 1904), pp. 445–466.

_____. "The High Building and Its Art." *Scribner's Magazine*, vol. 15 (March, 1894), pp. 297–318.

_____. "Modern Architecture." *New England Magazine*, vol. 7 (Janaury, 1893), pp. 601–606.

Fitzpatrick, F.W. "The Paucity of Ideas in American Architecture." *Architectural Record*, vol. 14 (July–December, 1908), pp. 395–396.

Flagg, Ernest. "American Architecture as Opposed to Architecture in America." *Architectural Record*, vol. 10 (October, 1900), pp. 178–180.

Goldberger, Paul. "A Life Renewed for 'Cathedral of Commerce'." *New York Times*, Thursday, November 5, 1981, p. B1.

Goodhue, Bertram G. "The Romanticist Point of View." *The Craftsman*, vol. 8 (June, 1905), p. 332.

Hamlin, A.D.F. "Twenty-five Years of American Architecture." *Architectural Record*, vol. 40 (July, 1916), pp. 1–14.

_____. "Style in Architecture." *The Craftsman*, vol. 8 (June, 1905), pp. 325–331.

Hastings, Thomas. "Architecture and Modern Life." *Harper's Monthly Magazine*, vol. 94 (February, 1897), pp. 402–408.

_____. "The Relations of Life to Style in Architecture." *Harper's Monthly Magazine*, vol. 88 (May, 1894), pp. 957–962.

Hood, Raymond M. "The Spirit of Modern Art." *Architectural Forum*, vol. 51 (November, 1929), pp. 445–448.

Hopkins, Alfred. "The American Renaissance." *Outlook*, vol. 98 (May 27, 1911), pp. 187–194.

Howells, William Dean. "Letters of An Altrurian Traveller." *The Cosmopolitan*, vol. 16 (January, 1894), pp. 20–33.

Jenkins, Charles E. "A White Enameled Building." *Architectural Record*, vol. 4 (January–March, 1895), pp. 299–306.

Kent, H. Harold. "The Chicago Tribune Competition." *Architectural Record*, vol. 53 (April, 1923), pp. 378–379.

Kimball, Fiske. "The Classic in the Skyscraper." *Architectural Record*, vol. 57 (February, 1925), pp. 189–190.

———. "Louis Sullivan — An Old Master." *Architectural Record*, vol. 57 (April, 1925), pp. 289–304.

———. "What Is Modern Architecture?" *The Nation*, vol. 119 (July, 1924), pp. 128–129.

Lamb, Frederick Stymetz. "Modern Use of the Gothic: The Possibilities of New Architectural Style." *The Craftsman*, vol. 8 (May, 1905), pp. 150–170.

Leonard, Louis. "What is Modernism?" *American Architect*, vol. 136 (November, 1929), pp. 22–25; 112.

Millet, F.D. "The Designers of the Fair." *Harper's Monthly Magazine*, vol. 85 (November, 1892), pp. 872–883.

Mumford, Lewis. "American Architecture To-day." *Architecture*, vol. 57 (April, 1928), pp. 181–188; vol. 57 (June, 1928), pp. 301–308; vol. 58 (October, 1928), pp. 189–198.

———. "Architecture and History." *Journal of the American Institute of Architects*, vol. 12 (April, 1924), pp. 191–192.

———. "The Buried Renaissance." *The New Freedom*, vol. 1 (March 15, 1930), pp. 12–13.

———. "Our Modern Style." *Journal of the American Institute of Architects*, vol. 12 (January, 1924), pp. 26–27.

———. "Two Chicago Fairs." *The New Republic*, vol. 65 (January 21, 1931), pp. 271–272.

Norton, Charles Eliot. "The Educational Value of the History of the Fine Arts." *Educational Review*, vol. 9 (April, 1895), pp. 343–348.

———. "Some Aspects of Civilization in America." *The Forum*, vol. 20 (February, 1896), pp. 641–651.

Peabody, Robert S. "Architecture and Democracy." *Harper's Magazine*, vol. 81 (July, 1890), pp. 219–222.

Peterson, Charles S. "The 1933 World's Fair." *Pencil Points*, vol. 10 (April, 1929), pp. 124–125.

Pond, Irving K. "Zoning and the Architecture of High Buildings." *Architectural Record*, vol. 35 (October, 1921), pp. 131–134.

———. "Let Us Embody the American Spirit in Our Architecture." *The Craftsman*, vol. 18 (April, 1910), pp. 67–69.

Price, C. Matlack. "A Renaissance in Commercial Architecture." *Architectural Record*, vol. 31 (May, 1912), pp. 449–469.

———. "The Trend of Architectural Thought in America." *The Century Magazine*, vol. 102 (September 1921), pp. 709–722.

Ralph, Julian. "Our Exposition at Chicago." *Harper's Magazine*, vol. 84 (January, 1892), pp. 205–215.

Reilly, C.H. "The Modern Renaissance in American Architecture." *Journal of the Royal Institute of British Architects*, vol. 17 (1909–1910), pp. 630–635.

Rowe, Colin. "Roots of American Architecture: an Answer to Mumford's Analysis." *Architectural Review*, vol. 116 (August, 1954), pp. 75–78.

Schuyler, Montgomery. "The Towers of Manhattan and Notes on the Woolworth Building." *Architectural Record*, vol. 33 (February, 1913), pp. 99–115.

Shepherd, William G. "Fair for Tomorrow." *Collier's Magazine*, vol. 90 (September 17, 1932), pp. 10–11; 49.

Skidmore, Louis. "The Hall of Science, A Century of Progress Exposition; Details of Structure and Equipment." *Architectural Forum*, vol. 57 (October, 1932), pp. 361–366.

Smith, Lyndon P. "The Schlesinger & Mayer Building." *Architectural Record*, vol. 16 (July, 1904), pp. 53–60.

Solon, Leon K. "The Passing of the Skyscraper Formula for Design." *Architectural Record*, vol. 55 (February, 1924), pp. 135–144.

"Starring a Star at Chicago Cubist Fair." *Literary Digest*, vol. 113 (May, 1932), p. 24.

Sturgis, Russell. "Good Things in Modern Architecture." *Architectural Record*, vol. 8 (July-September, 1898), pp. 92–110.

_____. "The Larkin Building in Buffalo." *Architectural Record*, vol. 23, (April, 1908), pp. 311–321.

Sullivan, Louis. "The Chicago Tribune Competition." *Architectural Record*, vol. 53 (February, 1923), pp. 151–157.

_____. "Reply to Mr. Frederick Stymetz Lamb on 'Modern Use of the Gothic; the Possibility of New Architectural Style'." *The Craftsman*, vol. 8 (June, 1905), pp. 336–338.

Swan, Herbert S. "Making the New York Zoning Ordinance Better." *Architectural Record*, vol. 35 (October, 1921), pp. 125–130.

Tallmadge, Thomas E. "Types, Past and Present." *American Architect*, vol. 129 (January, 1926), pp. 10–14.

Thorud, Bert M. "Engineering Research and Building Construction." *Architectural Forum*, vol. 59 (July, 1933), pp. 65–66.

"Tradition in Architecture." Field of Art Column. *Scribner's Magazine*, vol. 28 (October, 1900), pp. 787–788.

Tselos, Dimitri. "The Chicago Fair and the Myth of the 'Lost Cause'." *Journal of the Society of Architectural Historians*, vol. 26 (December, 1967), pp. 259–268.

Van Brunt, Henry. "The Columbian Exposition and American Civilization." *The Atlantic Monthly*, vol. 71 (May, 1893), pp. 577–588.

Van Rensselaer, Mariana G. "The Artistic Triumph of the Fair Builders." *Forum*, vol. 14 (December, 1892), pp. 527–540.

Walker, Howard. "Modern Architecture in Review: Style and Adaptation." *The Craftsman*, vol. 9 (October, 1905), pp. 36–40.

Index